Art Classics

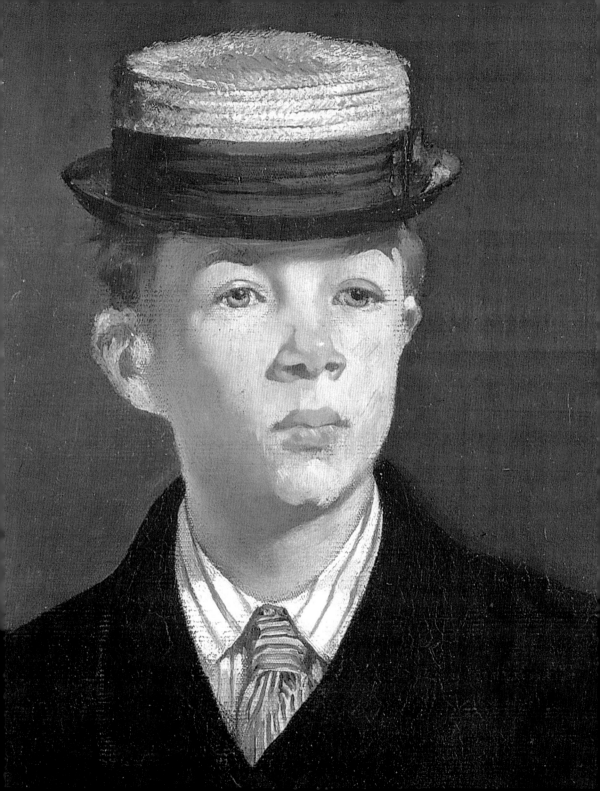

Art Classics

MANET

Preface by Marcello Venturi

ART CLASSICS

MANET

First published in the United States
of America in 2006 by
Rizzoli International Publications, Inc.
300 Park Avenue South
New York, NY 10010
www.rizzoliusa.com

Originally published in Italian by
Rizzoli Libri Illustrati
© 2004 RCS Libri Spa, Milano
All rights reserved
www.rcslibri.it
First edition 2003
Rizzoli \ Skira – Corriere della Sera

2005 2006 2007 2008 2009 /
10 9 8 7 6 5 4 3 2 1

Printed in China

ISBN-10: 0-8478-2910-3
ISBN-13: 978-0-8478-2910-1

Library of Congress Control
Number: 2006925810

Director of the series
Eileen Romano

Design
Marcello Francone

Editor, English-language edition
Alta L. Price

Translation
Miriam Hurley
(Buysschaert&Malerba, Milan)

Editing and layout
Buysschaert&Malerba, Milan

Cover
Le Fifre (The Fifer)
(detail), 1866
Paris, Musée d'Orsay

Frontispiece
Luncheon in the Studio
(detail), 1868
Munich, Neue Pinakothek

The publication of works owned by
the Soprintendenze has been made
possible by the Ministry for Cultural
Goods and Activities.

© Archivio Scala, Firenze, 2003

Contents

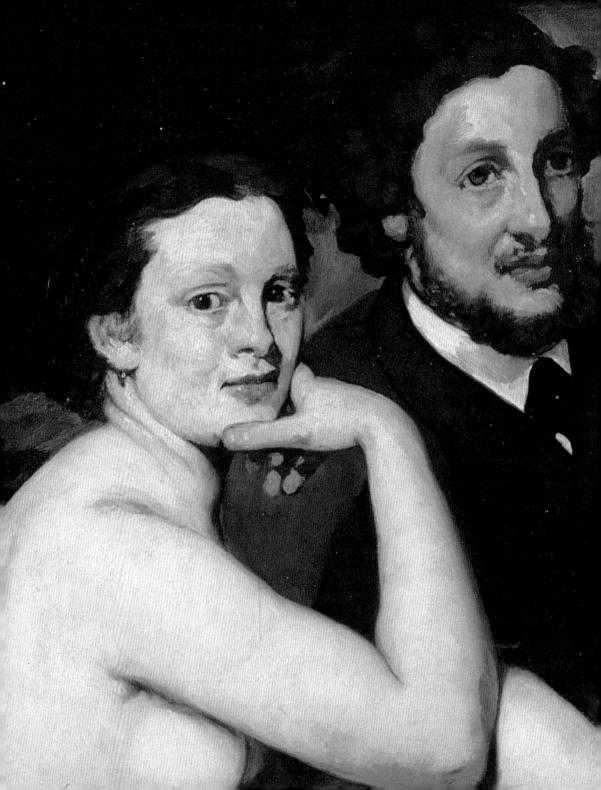

The Past as Inspiration for the Future
Marcello Venturi

"**I** wouldn't mind finally reading, while I'm still alive, the wonderful article you will dedicate to me after I'm dead." These few lines that Manet wrote to the critic Albert Wolff when his artistic career was nearing its end could serve as an insignia of the artist. He was not alone in this fate; in the conformist, conservative environment of the Second Empire, in the ferment of Paris on the cusp between two eras, official incomprehension and dislike were a tide against which almost all the great painters of the day had to struggle. Édouard Manet was special, perhaps, for the privilege of getting there first. He was the first to break the old stale systems and unleash the storm that would pave the way to impressionism and modern painting in general.

Was this a planned attacked or mere instinct? It is hard to imagine the mild-mannered Manet, an upper-class gentleman of elegant manners, even a proponent of bourgeois excess, in the role of a well-disguised explosive. If it were a planned attack, we would have to imagine Manet as a kind of Dr. Jekyll who roamed in broad daylight, with total humility and (perhaps false) admiration, the halls of Parisian and foreign museums to study the masterpieces of the past; and who, then, closed in his own studio, amused himself by creating what he had just seen, altering it to a ridiculous extreme. We must admit this idea has a certain charm, and we would be tempted to accept it. Yet, if we pause to look at *Le déjeuner sur l'herbe*, putting aside our spirit of adventure, or at least making an effort to curb the temptations of imagination, we will quite easily understand that Édouard Manet's love for the classics was sincere. What he had absorbed from

Le déjeuner sur l'herbe (detail), 1863 Paris, Musée d'Orsay

Giorgione and Titian, from Velázquez and Goya, lived on in him, though in that wonderful contrast between old and new that served as fuel for his denigrators. In *Le déjeuner* there is the hushed air and silence of paintings of many centuries past; there is also the sense that something from those centuries is over, that a world more unsettled, dissatisfied, and tense is already moving towards new conquests. These are not only conquests in art —they are also in daily life (the train, the so-called horseless carriage). Isolation is no longer possible, we now have to live amidst others, get a move on, and start running to keep pace with progress. A faint smile of skepticism or ironic detachment hovers over all this, directed not only at the world that is dying, but also anticipating a future attitude.

Manet studied and loved past masters, yet his language was necessarily modern. If a writer of his caliber sat down to rewrite the Italian classic *I promessi sposi* ("The Betrothed"), naïve Renzo, a tad dense in his goodness, would likely become a jaded character mistrustful of everyone. Angelic Lucia, a bit annoying in her immaculate purity, would take on more authentic, rougher tones. What fate would await a writer who dared as much? The same as Manet's fate—on the few occasions that his paintings were accepted at the Salon he had to bear the bemused laughter and scathing comments of the public, and, not to mention, the persecution of merciless critics. A contemporary journalist tells how the crowd thronged in front of *Olympia*, like in a viewing room at the morgue, with the same perverse curiosity with which they might look at a corpse. It seemed unacceptable that a Venus could have the look of a waitress, the face of a regular girl like any other you might meet on the street. Even the little dark spot on the right in which the figure (or the essence, really) of the cat hides only added to the irritation. It was the very idea of beauty that was subverted. Yet Manet sincerely tried to explain to people his modest, not at all revolutionary intentions. "It is the effect," he wrote, "of sincerity that gives

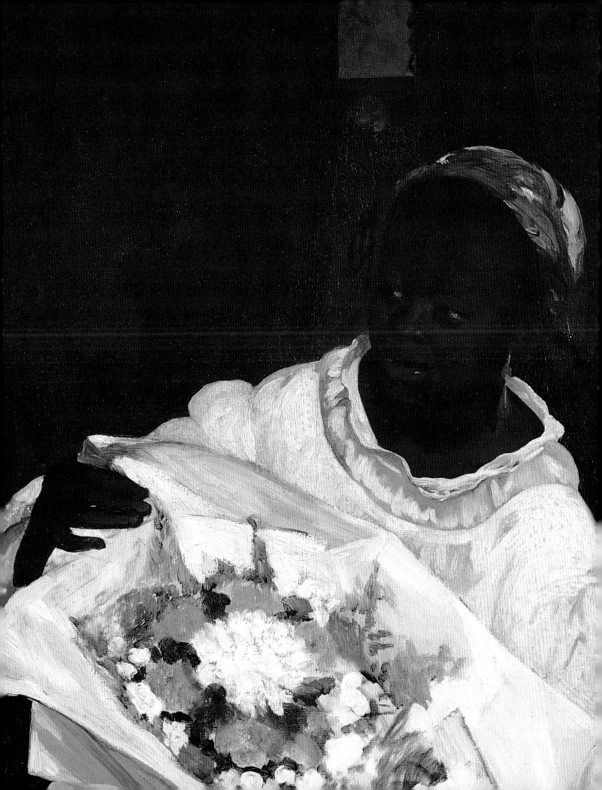

to a painter's works a character that makes them resemble a protest, whereas the painter has only thought of rendering his impression. ... He does not seek to overturn tradition or create a new painting style. He simply wishes to be himself and no one else." People refused to believe the truth of his statements. Moreover, this very need for sincerity led Manet to destroy myths. While he worked starting from tradition, as he went along, he broke down that tradition. He was too interested in daily life to forget, for even a second, the barmaids at the Folies-Bergère, the concierge of Rue d'Amsterdam, or a drunkard glimpsed in the night.

Painting after painting, image after image, he sought the discovery of that epic aspect that can be found behind an everyday tie or dress, as his friend Baudelaire said. Yet let's be clear: this epic aspect is one of flesh and blood, one that each of us unconsciously carriers within, and is part of the human condition in which we live. In other words, it is our greatness as mere mortals struggling with the infinite difficulties of life, our weaknesses, and our hardships. Our falls. Because in our weaknesses and hardships, in this struggle to survive, in succumbing or overcoming, there is something a lot like heroism. This heroism is not rhetorical, but is simply lived, cast-off and weary, one that we can see in the very lights and shadows of *The Absinthe Drinker*. Comparing Manet to Chekhov, it could be said that the painter, like the great Russian writer, was more interested in the experience of the character than in the stage on which he acted. Specifically, he was interested in the experience of the average, anonymous person set to become the new protagonist of a coming history. This anti-rhetorical taste of his, a taste for debunking and demythologizing, comes out even when Manet's brush draws from episodes of official history.

For instance, it is evident in the painting of Maximilian's execution: a squad of soldiers empties its rifles at the targets' chests, with a natural and calm manner as if they were playing a game at an

amusement park. One of the soldiers stands outside the squad and is checking his rifle's loader because isn't working. Unmoved, indifferent to the tragedy taking place a few steps away, he seems more concerned with the functioning of his weapon than the presence of death. A few spectators, including a woman, are looking on over a dividing wall. One of these looks like a skull, yet no one betrays anything more than cool curiosity. This work lacks the violence of the Goya piece that Manet had in mind, yet there's a kind of greater brutality, a coolly mechanical determination, that somehow anticipates the mass slaughters to come in the future. No longer imitations, no longer celebrations just the pitiless study of fact. This may have been another element that disturbed the consciousness of the proper Parisian bourgeoisie. Manet's paintings were disliked for the truth and accusations they contained, in addition to his innovations in colors and forms, those contrasting grays and whites to which contemporary eyes were not accustomed.

The desperate survivors of an era already heading towards its decline wanted to be left, for a while longer, in their blessed illusions of stability—at least when it came to art—pretending not to hear the roar of canons that were already thundering in the countryside outside Paris. Of course, he did have his supporters, those who were able to understand the innovative greatness of his art. Every impulse of culture, or lack of culture, has its exceptions. In the swarming, shabby cafes of the boulevards, in which a full-fledged literary society was forming, the voices of Baudelaire, Mallarmé, and Zola were quick to rise to his defense. They also defended him in the columns of leading Parisian papers, taking up his cause against the academic gurus. A circle started to form around Manet's vibrant personality, as around a master, consisting of the painters who would soon give rise to impressionism. Zola wrote indignantly in the aftermath of one of Manet's many rejections from the Salon, "There are very many artists who are considered great today and paid piles of money; yet, I would not

trade one painting by Manet for all their paintings. The day will come in which not one work by them will remain, but Manet's works will." A famous Parisian baritone, Faure, was of the same opinion as Zola and collected a major number of Manet's works. Official recognitions finally arrived as well, though they were few and due primarily to his friend Antonin Proust, and came only when Manet, felled by illness, was coming to the end of his trajectory.

"Trajectory" is not quite the right word. We should rather say it was at the end of his greatest height. It was in this very period of physical suffering that he painted one of his finest works, *A Bar at the Folies-Bergère.* Amidst the lights and shine of the bottles and glasses, multiplying in the magical series of mirrors, we will never tire of delving into the gaze of the immobile girl behind the counter. That gaze holds a mystery that we are each free to try to decipher. There is a true presentiment, behind these moist eyes, of an infinite melancholy. It is the melancholy of distant seas that Manet knew in his youth aboard the cargo ship *La Guadeloupe.* It is the melancholy and sorrow of an embattled life, yet also the lively and fruitful life that the painter felt ebbing from his veins day by day. Perhaps it is a premonition of death. No more light, no more colors, no more faces, voices, and feelings to capture on canvas, to rip from nature and fix there forever. Instead, there is the certainty of darkness. We sink into the mystery of those eyes, which little by little reveal themselves, and uncover themselves to let us glimpse other realms and dimensions. We sink into them in the same way, with the same helpless anxiety, that we get lost in a piece of Wagner's music, his *Prelude* and *Isolde's Liebestod,* where the author manages to materially touch the very essence of our destruction. Yet even in this final message Manet's tone does not waiver from the reality of the things and feelings that had informed his entire progression. The girl stands still, waiting and

contemplating, with the humility and acceptance of a predestined victim. She has no anger, nor any sense of rebellion, just the awareness of her presence, and is only slightly perturbed by the feeling of finding herself on the threshold of something unknown. Manet gave a farewell to this world that he loved so much and that had been so stingy with its satisfactions.

Only after he died did the unanimous chorus of acknowledgment rise, as is always the case for those whose greatness puts them ahead of their time. The funeral procession headed towards Passy cemetery, made up of a crowd of painters, writers, government officials, and a large group of women. There was even a guard of honor from the army to attend his burial. Rising on a cushion was the ribbon of the Legion of Honor, which his friend Antonin had gotten for him. A perfect staging, and an evident wish to make amends. Perhaps everyone there, friends and enemies alike, was aware of it. Indeed, it was at this point, as they gathered among the white gravestones, that Degas, perhaps with great prescience, pronounced the *mea culpa* of an entire society: "He was greater than we thought," he said.

Portrait of Émile Zola (detail), 1868 Paris, Musée d'Orsay

following pages *Woman with Fans* (detail), 1873–1874 Paris, Musée d'Orsay

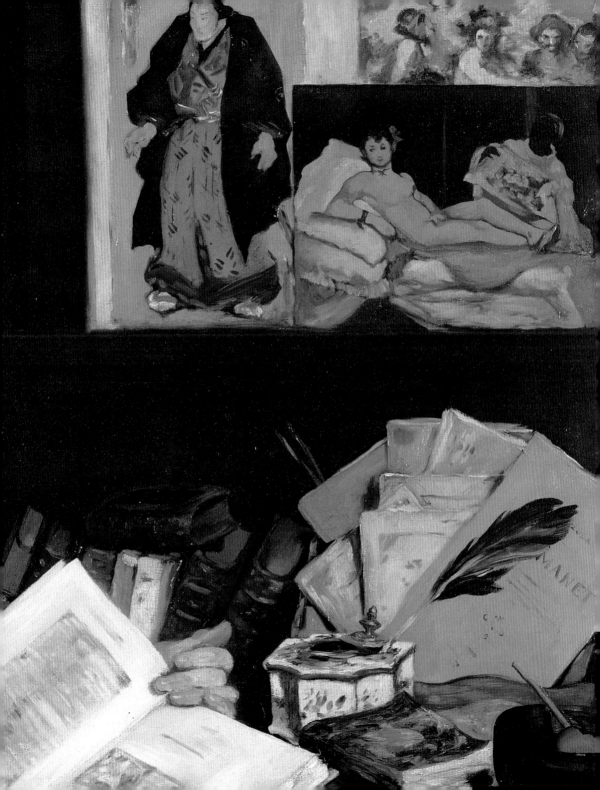

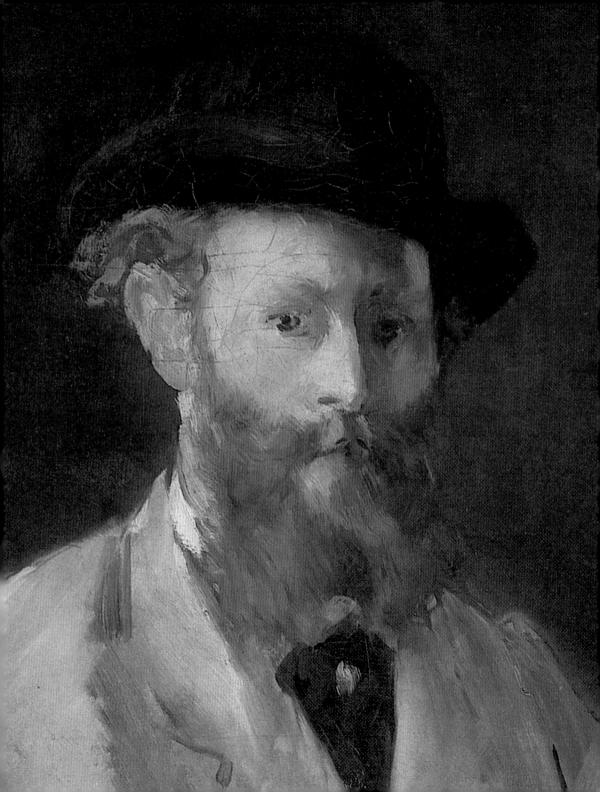

His Life and Art

Édouard Manet is associated with the impressionists and was long considered one by art historians. However, though he was friends with many members of that group, Manet was not actually a true impressionist.

Renoir had clearly stated his role in relationship to them, later illustrated by a series of studies and exhibitions: "Manet was as significant for us as Cimabue or Giotto was for the Italians of the Renaissance." He was a conceptual leader and source of inspiration, a master who had shook up the era's artistic world, but whose style did not coincide with that of the new generations. Though his palette grew lighter with the passage of time, it never matched the vibrations of Monet's palette, and he never juxtaposed pure colors.

Furthermore, unlike the majority of impressionists, who recognized the Barbizon painters as their predecessors, and who painted *en plein air* in a village on the edges of the Fontainebleau forest, Manet was not a landscape artist. He worked, with rare exceptions, within the walls of his studio. His teachers and idols, in addition to the realist painter Gustave Courbet, were the great masters of the past: Raphael, Titian, Goya, and Velázquez. Significantly, Manet always sought success within official institutions, starting with the Salon.

He invariably refused to exhibit at the impressionist shows, though he spent much time in the company of his young colleagues and tried to support them.

Not coincidentally, Edgar Degas was the artist in the group with which he had the most in common, as he was "the least impressionist of the impressionists," and who, though he participated in their group shows, rejected the label, considering himself a realist. Degas and Manet shared a common choice of subjects associated with the new rhythms and gathering places of city life, as well as their upper class backgrounds.

Manet was born in 1832 in Paris, the first son of a high officer of the Minister of Justice and a diplomat's daughter. Despite the fact that they lived virtually across the street from the École des Beaux-Arts, a monument to official art, his family in no way encouraged his interest in painting, and, in fact, they did everything to oppose their eldest son's vocation. Manet completed his classical studies at the prestigious Collége Rollin, where he met Antonin Proust, who became his faithful lifelong friend. As a young student, Manet often went to the Louvre with Proust and a maternal uncle and started drawing.

Though his passion for fine arts continued to grow, his father forbade him from dedicating himself to art and wanted him to study law instead. In 1848, to spite him, Édouard tried to enter the Naval Academy when he finished the Collége. Though he failed his exams, he started training as a sea cadet on a voyage to Rio de Janeiro. He tried the exam again upon his return. When he failed once again his father was persuaded to let him try a career in painting.

In the late 1840s the French art world was dominated by the Salons, large biennial exhibitions in Paris that determined the success or failure of painters and sculptors. Anyone was free to present their works to be exhibited, but they had to face the irrevocable judgment of a jury who chose to accept or reject them. This mechanism made the Salons highly undemocratic. Far from representing the diverse trends in art of the time, the jury was composed exclusively of members of the Académie des Beaux-Arts, the national institute that also selected teachers at the École des Beaux-Arts, and who rejected almost all works outside of strict tradition. By far the greatest success was given to historic paintings, with their rhetorical, mythological, historic, or literary scenes,

followed by portraits, still lives and a landscape every once in a while.

Artists who triumphed included followers of the Neoclassical painter Ingres. The Romantic school of Eugène Delacroix was also making laborious headway in establishing itself. Naturally, there were dissidents (Millet's peasant painting, the nascent Realism spearheaded by Gustave Courbet, and the Barbizon landscape painters, who painted with a freedom considered excessive), who sought innovative styles and subjects. They were systematically excluded from the official stage. Manet decided to enroll in classes with the painter Thomas Couture, who had triumphed at the Salon in 1847 with a large painting, *The Romans of the Decadence* (Paris, Musée d'Orsay). Couture had been a student of Antoine-Jean Gros, heir of the great Neoclassical painter Jacques-Louis David. He was on his way to becoming a top artist of the Second Empire, and was greatly admired by Napoleon III.

Spending time in his studio meant becoming part of the uppermost ranks of officialdom and joining the favored group of Academy professors. Though his upper=class background should have naturally oriented him towards this type of painting, Manet turned out to be very critical of his teacher's painting and methods. In fact, he openly disdained a large part of Couture' s methods. In his memoirs, Antoine Proust recalled his friend's impatience with the scenery and the poses' unnatural quality: "Of course I know we can't have models undressing in the street. But there's the countryside and in the summer at least we could do nude studies out in the open…. Do you stand like that when you go to buy a bunch of radishes at your greengrocer's?".

All the same, Manet stayed with Couture for six years, making several study trips of great importance for his development. In 1852, he went to Holland,

where he copied several Rembrandts. The year after that, he visited Austria and Germany. In 1853, he and his brother Eugène headed for Italy where he copied the *Portrait of a Youth* by Filippo Lippi and Titian' s *Venus of Urbino* (Florence, Uffizi).

The practice of copying past masters was one of the foundations of academic teaching, and Manet devoted himself diligently to the pursuit. When he returned home, he went to Delacroix to get permission to copy *Dante and Virgil in the Inferno* (Paris, Louvre). Later he would often use ancient works as clear sources of inspiration for his paintings. A few years earlier, in 1849, he had started taking piano lessons from a young Dutch teacher, Suzanne Leenhoff, who quickly became his mistress. In 1852 she had a son, Léon, of whose Manet's paternity is assumed, though it has never been verified, as Manet did not give the child his last name. In 1856 Manet left Couture. The year before had been packed with events in the artistic world. A large universal exposition had been held in Paris, the second one after the London exposition of 1851, which had given much room to figurative arts. Ingres and Delacroix came out triumphant, and all representatives of academic painting, from Couture on, won prizes. Landscape painters associated with the Barbizon school were poorly represented. Corot had six works, Daubigny even fewer, and Millet just one. Courbet, whose works had been rejected, had built a Pavilion of Realism at his own expense across from the official spaces, setting up an insolent individual show. As could be predicted, the project did not meet with resounding success, but Courbet had set forth his revolutionary plan: "translate the customs, ideas, and appearance of my times as I see them—in a word, to create a living art."

Manet's criticisms of Couture were in complete accord with Courbet's ideas, even though his works had a less rough execu-

tion, and the subjects were not workers or farmers. The first work that Manet presented at the Salon in 1859 did feature an eminently common figure: *The Absinthe Drinker*. The painting, based on brown tones, depicts a man in a top hat and cloak, leaning against a short wall where the glass of liquor is set. Despite some uncertainty in the figure's construction, the painting has undeniable power, and the figure of the drunk fully fit with Courbet's provocative plan. The painting was supported exclusively by the now aged Delacroix, who had finally managed to become part of the jury. Nevertheless, his support did not suffice and the painting was rejected.

In the same year, Manet met Edgar Degas, son of a wealthy banker, while busy copying a portrait by Velázquez at the Louvre. Velázquez, the great eighteenth-century Spanish painter, fascinated Manet, who took direct inspiration from him for his first work accepted by the Salon in 1861, *The Guitarist*. Like his painting two years earlier, this one had a very simple compositional system; the figure was constructed solely with color. However, its common folk atmosphere made it considerably more appealing. Though it was initially poorly displayed (the paintings covered the entirety of the high-ceilinged rooms; those hung up high could barely be seen at all), it received official acknowledgement with an honorable mention, and attracted the admiration of a group of painters, including Fantin-Latour and Carolus-Duran, young Courbet admirers. These two painters formed a delegation that went to Manet's studio to pay respects to the new talent.

Other visitors included the critics Castagnary, Astruc, Desnoyers, Champfleury, and Duranty, who were writing to champion realism. Led by Courbet, the group met at the Brasserie des Martyrs (cafés were the prime gathering places of the various artistic

factions). Yet Manet never joined them there. Though he was fighting the same battle as they were in favor of new art, he did not wish to be taken for a revolutionary.

First of all, he was seeking success within the official channels, and his recent success at the Salon gave him hope, discouraging him from compromising himself. Furthermore, he had no aspirations whatsoever to become a bohemian. He preferred the more elegant Café Tortoni, where Parisian high society met. Through the realists he met the poet Charles Baudelaire, who took part in their meetings and brought his great intuition and sensibility to art criticism. The two quickly became friends. In 1862 Baudelaire wrote an article extolling the work of his new friend. The following year he published an essay in *Le Figaro* called "The Painter of Modern Life" dedicated to the shy Constantin Guys, an artist admired by Manet as well.

Baudelaire sketched the profile of the modern artist, describing him as a dandy

who had grasped the essence of contemporary life—all that is fleeting, transitory, and morphing. His task was to immortalize the ephemeral nature of the present, capturing its poetic outlines while rejecting paintings of literary subjects or mythological reconstructions. He stressed: "The past is interesting not only for the beauty which the artists for whom it was the present were able to extract from it, but also as past, for its historical value. The same is true of the present. The pleasure we derive from the representation of the present is drawn not only from the beauty in which it can be clothed, but also from its essential quality of presentness."

Manet quickly responded to Baudelaire's essay with the painting *Music in the Tuileries*, which he exhibited in 1863 in Louis Martinet's gallery, along with ten other works. Though the small exhibition greatly impressed a young Claude Monet, it was not as well received by the critics, who harshly termed Manet's paintings a "caricature of color." The episode did not bode well for the jury's decisions on the works to accept to the Salon. Indeed, despite the honorable mention received two years earlier, his works were rejected. Manet was not alone in being excluded. Some three-fourths of the entries were rejected. Such a completely unprecedented judgment could not be without consequences. Showing at the Salon meant being known and, more importantly, appreciated by the public, to the extent that excluded artists were invariably without buyers and even paintings already purchased were returned to their creators if rejected from the Salon.

There was a widespread revolt of the rejected painters. The proposal by the gallery owner Martinet to exhibit their works himself proved impossible due to their large number. The voices of dissent even reached Napoleon III's ears and he came in person to examine the rejected works. In a highly uncommon

decision, the emperor ordained the opening of a *Salon des Refusés* where the rejected artists could exhibit their paintings. While many painters, including Manet and Courbet, were happy about this turn of events, not everyone chose to exhibit, as doing so would definitively alienate the jury, which, for its part, did everything in its power to put the counter-exhibition in a bad light, placing the worst paintings in the most visible spaces. Though the realists, who were open dissenters, were not concerned on this front, the risk was real for those seeking official success, given the rebellious precedent of the Pavilion of 1855. Over six hundred works of the three thousand rejected were withdrawn. Though Manet was certainly not seeking a reputation as a revolutionary, he did not want to miss the chance to be seen by the public in a setting that had received the emperor's backing, and he showed his rejected works. As the pessimists expected, the Salon des Refusés was a total disaster as

far as the public reaction went, and the "triumph of the rejected painters" quickly became the "triumph of the jury." The exhibition drew an enormous curious crowd who, incited by the press, burst into "fits of unstoppable laughter". Alexandre Astruc lamented bitterly in an article that "you have to be strong twice over, to survive the storm of idiots that are raining down here in the millions and mocking everything to death." There were three artists who "enjoyed" the brunt of all the ridicule: James McNeill Whistler, the American transplanted in Paris, Gustave Courbet, branded the "most rejected of the rejected" because one of his works was rejected from the counter-exhibition for moral reasons, and, of course, Manet.

Two of the three paintings he presented had Spanish subjects, and the third would go down in history as one of the most revolutionary paintings of the modern era: *Le déjeuner sur l'herbe*. Though the work drew on classical models, what was shocking, beyond

the freedom of its style of execution, was the subject. Rather than a mythological scene, Manet had depicted a slice of contemporary life. The female nude was not the traditional nude of a nymph, and the two men were wearing modern clothes instead of historic robes.

Despite its clear cultured sources, inspired by the Italian Renaissance, the work was accused of indecency. Manet gained a reputation as a painter set out to scandalize, which was exactly the opposite of what he wanted. The effect was aggravated by a visit from the emperor himself. He stopped right in front of the incriminated painting, agreed with the criticisms, and branded it an affront to common decency. Napoleon III's attention only fanned the flames of the controversy. The critic Théodore Duret noted in retrospect: "Manet suddenly became the most talked-about painter in Paris!"

Despite the Salon des Refusés' failure, the central government had understood that

its mechanisms for governing the art scene were in need of some reform. An imperial decree in November of the same year took the right to appoint teachers to the École des Beaux-Arts away from the Academy, determined that the frequency of the Salon be annual, and most importantly, that three-fourths of the jury were elected by the artists who had already exhibited at the official show. The Refusés were still kept out, and only those accepted painters who had been awarded a medal enjoyed the right to vote. It was a small step forward, but was indeed enough to provide increased freedom in the decisions of the jury members, and allowed Manet to return to the Salon.

In 1864 Manet (who had married Suzanne in the meantime) exhibited a large religious composition, *Dead Christ and the Angels*, along with another Spanish-themed painting. Its extreme freedom in execution, considered intentionally sacrile-

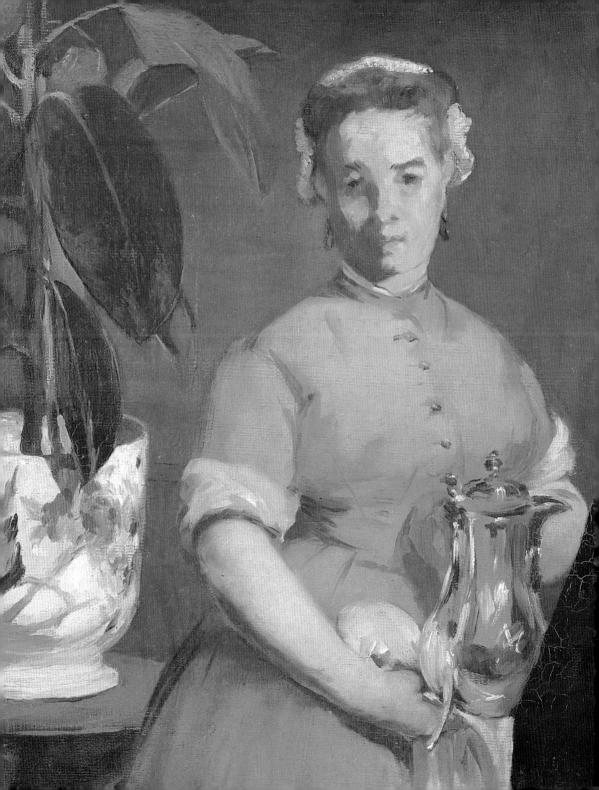

gious, again raised widespread censure. The criticisms in the press were nothing compared to what happened the next year. Manet continued undeterred on the path he had undertaken, making no concessions to bourgeois niceties. Convinced his work would earn its deserved acclaim, he finished another female nude which drew directly on the great Italian tradition, like *Le déjeuner sur l'herbe*. Yet in the new painting he did not stop at representing a subject taken from contemporary life. The young woman reclined on an unmade bed, gazing directly at the viewer, unambiguously represented a prostitute. *Olympia*, "Odalisque with a yellow stomach" (as critic Jules Claretie contemptuously called her), unleashed furious controversy, and even Courbet condemned the work. The critic Louis Leroy stated: "If I were ever to write a single line of praise for *Olympia*, I give you permission to expose me in public… ." Manet's reputation as a revolutionary and provocateur who was only able to play the card of moral insult to get attention reached an all-time high. He was so upset by it, despite an encouraging letter from Baudelaire, that he decided to leave on a trip to Spain a few months later.

Thus, he visited for the first time the country that had supplied so much of his inspiration and subjects for his work. In 1864 a satirical cartoon dubbed him "Don Manet y Courbetos y Zurbaran de las Batignolas." Manet had doubtlessly formed an idealized image of the country of artists that he so highly esteemed, and his vision had little in common with reality. When he returned to France, he abandoned folk scenes and concentrated exclusively on representing modern life. At the new Salon, he presented two works which, at least in terms of subject, were in no way anti-conformist, *Le Fifre* (*The Fifer*) and *The Tragic Actor*. Yet the *Olympia* scandal was too fresh, and Manet's name was still tied to exclusion from the official stage.

Both works were rejected. Manet would soon find a new public supporter in the young Émile Zola, a brilliant new writer and journalist. Zola was a childhood friend of Cézanne's and had great passion for art, together with a mordent pen and flair for critical militancy. As Baudelaire had done, Zola recognized Manet's talent and challenged, in no uncertain terms, "the position assigned him as a pariah, as an unpopular and grotesque painter." He wrote an essay about him in the pages of *L'Événement* "Manet at the Salon of 1866," a title in itself provocative, given that the painter's works had been rejected by the exhibition. Praising *Le Fifre*, one of the rejected paintings, Zola extolled Manet's entire body of work, its "authenticity and simplicity" which were so far from the typical affectations of Salon art. Manet, on the contrary, was "a man who directly addressed nature, and brought all of art into question." Zola astutely noted that his works, unlike those in fashion, "simply burst open the walls." As with Baudelaire, the two formed a strong friendship. Soon thereafter Manet met Paul Cézanne, as well as Claude Monet, whose landscapes, given the similarity of their last names, had been mistaken for Manet's works at the Salon.

Weary of ostracism by the jury, Manet took up a new tactic the next year. He did not present works to the committee. Instead, he organized a personal show, as did Gustave Courbet, repeating his experience of 1855. At any rate, for Manet it was, as usual, not about distinguishing himself as a dissident. The exhibition had an explanatory note, almost certainly Astruc's work, that clarified his intentions: "Since 1861 Manet has been exhibiting or trying to exhibit.... Manet has never wished to protest. The protest was directly against him without his deserving it." The firmly rooted prejudices against him were not easy to knock down, and the show

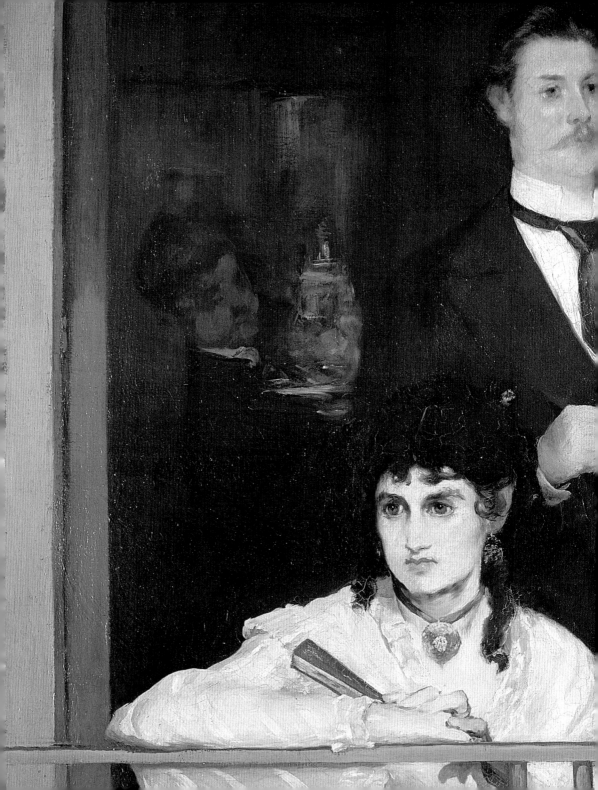

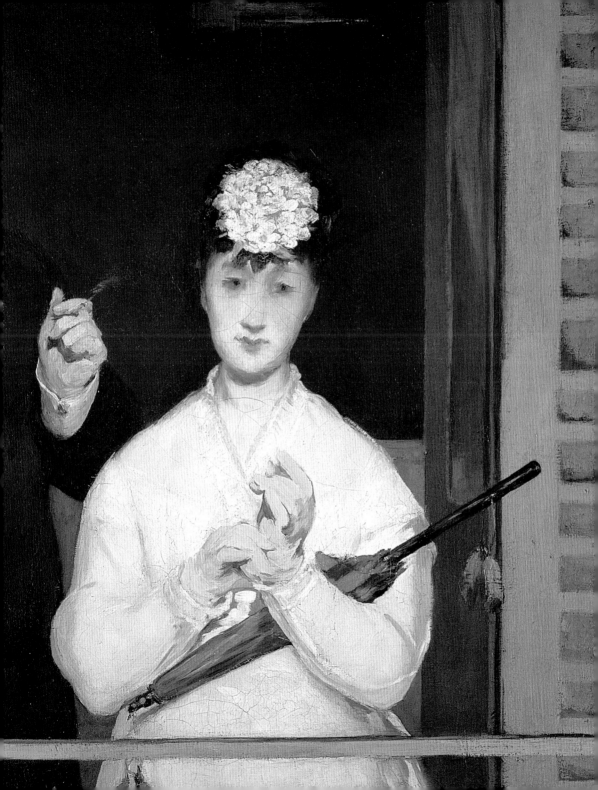

was another failure. Despite the admiration of his young colleagues (though even Courbet no longer admired him) the public was not yet equipped to understand his anti-rhetorical style. Those who admired him were, moreover, in his same situation and also found it hard to get accepted to the Salon. Except for Degas, a great admirer of Ingres and a faithful figure painter, with no interest at all for *plein air* painting, this was a group of artists working on studying the effects of light, its reflections on plants, water and materials, painting with great freshness and a vibrant touch.

Monet, Renoir, Pissarro, Sisley, Cézanne, and Bazille admired the naturalness of Manet's style, his fluid brushstrokes, and his independence from the dictates of academic art. The group, led by Manet himself, started to meet at Café Guerbois on Rue de Batignolles. Other participants at the meetings included the realist painter Fantin-Latour, the critics Astruc, Duranty, Zola, and, occasionally, the photographer Nadar. Soon Berthe Morisot, a young woman from a wealthy family, joined them and immediately enchanted Manet, for whom she would pose on several occasions. Discussions at Café Guerbois mainly revolved around purely artistic matters, starting with Japanese prints, which all the painters (who still had such diverse individual interests that they were never defined as a school) had had a chance to admire at the Universal Exhibition of 1867. Manet included one in the background of a portrait of Émile Zola exhibited at the Salon in 1868. After the failure of his individual show the year before, Manet had decided to return to the official route, encouraged by the fact that Charles Daubigny, one of the Barbizon landscape painters, was on the jury. Thanks to his ardent support, the works presented by Manet were accepted, though poorly displayed. This was also the case for the

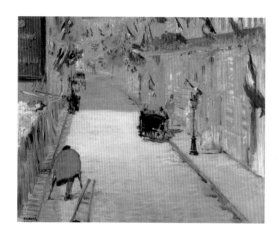

group of young painters, except for the more
anti-conformist Cézanne, who intentionally
sent his most subversive paintings in an obsti-
nate attempt to discredit the jury. Exhibiting
at the Salon was still an issue given the
scarcity of galleries in which to present one's
work without the filter of academic judg-
ment (a private commercial system, inexis-
tent in the mid-nineteenth century, was just
starting to form in these years). The group
had planned to rent a warehouse and put
up a self-organized show. However, given
the meager finances of most of the artists, the
project failed and the next year they again
subjected themselves to the Salon.

On the other hand, it was essential to
present to the public. Given the proven
failure of alternative initiatives, as well as
the poverty of many of the artists and their
need to sell, there were few discontent artists
who openly rebelled against the official
mechanism. In 1869 a new regulation had
been introduced that revealed a more liberal

management of the nominations. Every artist who had had at least one work accepted in the past gained the right to vote to elect the jury. Except for Cézanne, all of the group's painters were able to express a preference. The new procedure, however, proved ineffective because most of the participants were aligned with the academic world. As such, Daubigny was reelected, but the other great landscape painter, Corot, was not. Manet had two works accepted, but Monet and Sisley (though they'd been accepted in the past) were rejected. One of Manet's paintings, *The Balcony*, included Berthe Morisot as one of the figures. In the same period, Manet met a young Spanish woman, Eva Gonzales, the daughter of a fashionable novelist. Igniting Morisot's jealousy, Manet took Gonzales on as a student (she was the only person he agreed to teach). Yet, the pairing did not last long and the artist soon went back to using Berthe (whose artistic talents were also considerably greater than

Gonzales) as a model. Manet spent the summer with his family in Boulogne-sur-Mer, where he painted some *plein air* seascapes. The discussions of his younger colleagues must have made an impression on him. In his new works, he abandoned references to past masters, still clearly present in *The Balcony*, and focused on paintings of great freshness and vivacity. Antonin Proust references a statement made by Manet: "That's what people don't fully understand yet, that one doesn't paint a landscape, a seascape, a figure; one paints the effect of a time of day on a landscape, a seascape, or a figure."

The word "impression," already in use in artistic circles, would within a few years give the name to the revolutionary style of Claude Monet and his friends. Manet himself, though he only painted landscapes occasionally, was changing his way of painting in certain ways, using a lighter and more luminous palette and more dynamic arrangements for some of his works.

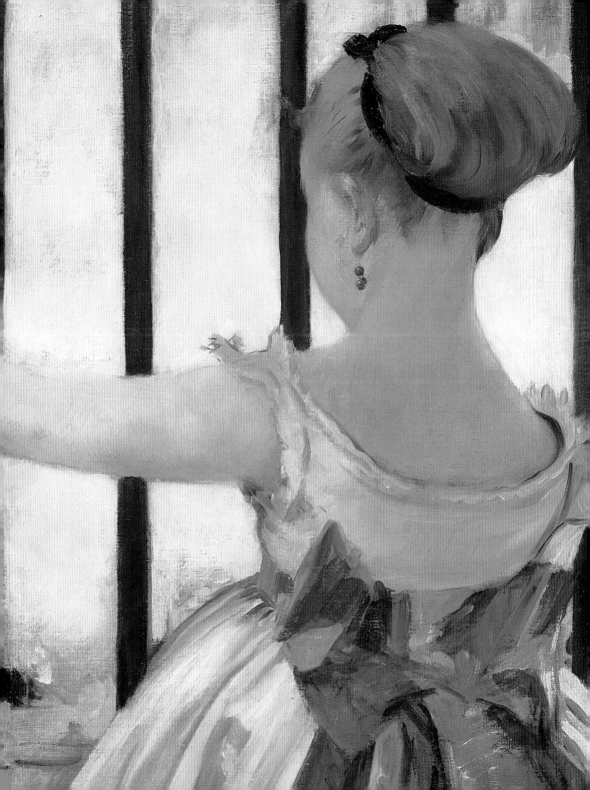

The year 1870 was eventful. The artists in the group who had the right to vote in the Salon crafted a list of jury members to their liking, asking Zola to publish it in the newspapers to give them publicity. Academic painters were off the list and replaced by Manet, Corot, Daubigny, Millet, Courbet, the realist painters, Daumier, and others. Not only was the project a failure, it compromised the positions of Corot and Daubigny, the only two who had been part of the jury in the past and had been reelected. Finding themselves marginalized, both chose to quit. Daubigny publicly declared that his gesture was a result of the exclusion of Monet, who became the main target of the Academy's vendetta. The others had at least one work accepted. Manet showed two paintings, including *The Portrait of Eva Gonzales*, and Fantin-Latour showed *Un Atelier a Batignolles* (Musée d'Orsay, Paris). A few years before, Fantin-Latour had painted *Homage to Delacroix*, in which the artist himself, Manet, Whistler, Baudelaire, Champfleury, Duranty, and a few others were gathered around a portrait of the recently-deceased master. Taking back up the idea, Fantin-Latour now celebrated Manet as the group's leader, portraying Renoir, Monet, Bazille, and the writers Zola and Astruc next to Manet while he worked. The work attracted notice and a caricature was dedicated to it, called *Jesus Painting amidst His Disciples*.

During the summer, galvanized by Bismarck's maneuvers, France declared war against Prussia. The German army was far superior, and the conflict ended a few months later with a brutal defeat in Sedan and the fall of the Second Empire. While many of his colleagues fled, Manet, a staunch Republican, stayed in Paris and enrolled, along with Degas, in the armed guard. In September the German

41

armed forces put Paris under a merciless siege, and it surrendered in January. The new government was deposed by a popular insurrection which led to the institution of the new administration, called the Commune. Courbet gained an administrative role and also became president of the artistic commission that abolished the École and Académie des Beaux-Arts, as well as the Salon's medals. In April, Manet was elected as one of the delegates of a federation of artists. However, he never took the position, as he had left several months earlier to meet his family, who had been in the Pyrenees since the battles began. The Commune was soon bloodily suppressed and Courbet was put in prison. Manet had never shared his colleagues' ideas, had long admired the new minister, Gambetta, and happily welcomed the birth of the Third Republic. In 1872, the Salon started back up and Manet exhibited *The Battle between the Kearsarge and the Alabama,* which he had painted in 1864, the day after a battle off the coast of Cherbourg between two ships from opposing factions in the American Civil War.

Another situation was of far greater import for the Batignolles group. During the war against Prussia, Pissarro and Monet had taken refuge in London, where Daubigny was. Daubigny, who in the recent past had expressed his esteem for Monet (reduced to a state of near destitution), introduced him to his art dealer Paul Durand-Ruel in early 1871. In the 1870s, a small network of private galleries was starting to form, which directly sold works of art. Durand-Ruel was an avant-gard dealer, son of the man who first focused on the Barbizon school. He had already recognized Monet's talent in the few paintings he had seen in Paris. When Manet introduced himself to the London gallery, the dealer immediately bought some paintings, paying 300 francs for each. He did likewise with

Portrait of Antonin Proust,
1877–1880
Moscow, Puškin Museum

Pissarro, whose work he bought for 200 francs each. With the end of the Commune, the dealer returned to Paris, buying works by Courbet (whom he continued to support even though he had fallen into disgrace due to his political involvement), by Barbizon landscape painters, for some of whom he held the exclusive rights, as well as his new protégés and their friends, including Degas and Sisley. Manet was definitely the most well-known of the group. Durand-Ruel chose to invest in him quite substantially.

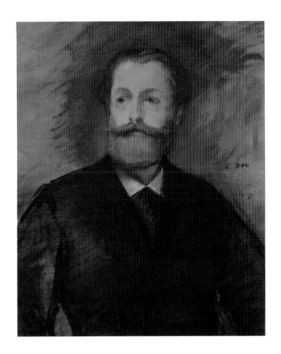

In January 1872, in the studio of a successful artist named Alfred Stevens, he was impressed by a still life and night time view of the gate of Boulogne by Manet. The artist had left the works with Stevens, who was his friend, in the hopes of finding a buyer, given Stevens' fame. Beyond buying the two works immediately, Durand-Ruel went to Manet the next day and brought all twenty-three paintings in his studio en bloc (a practice which he adopted more than

once) paying him a total of 35,000 francs. Manet's prices were high compared to those of his younger colleagues, ranging from 400 francs to 3,000 francs for *The Guitarist*, awarded at the Salon in 1861. The amount offered by Durand-Ruel was, nonetheless, exceptional. Manet made haste to get back the works he had left with friends and these were also bought by Durand-Ruel, who immediately organized a series of shows at the Society of French Artists in London, presenting his new discoveries.

The exhibitions gave a good overview of the pursuits of the Batignolles group. Manet had thirteen works shown; Pissarro, nine; Sisley, six; Monet, four; Degas, three; and Renoir, one. The project, repeated in small versions the following two years, did not meet with the hoped-for success, and Durand-Ruel did not manage to sell even one painting. He was no mere speculator, believing sincerely in the need to support innovative artists and invest based on his own aesthetic convictions. Durand-Ruel's entrance on the scene, as he was busy preparing a colossal, three-volume catalogue of the paintings he owned, convinced several artists in the group to not present at the Salon, which incensed Manet, who still had the same ideas about the official exhibition and kept on seeking public approval in official places. This time his faithfulness was rewarded, and, he had great success with *Le Bon Bock*, a portrait set at a table of Café Guerbois.

As had happened exactly ten years earlier, the jury was very restrictive, rejecting many paintings and artists. The same circumstances were in place once again as those that had led to the opening of the Salon de Refusés. The ministry looked for a shortcut to avoid raising the uproar of the past and nominated a second jury with wider perspectives, to which rejected artists could present their works. Many of these, for the same reasons as in 1863, namely to avoid suffering consequences in the future, withdrew.

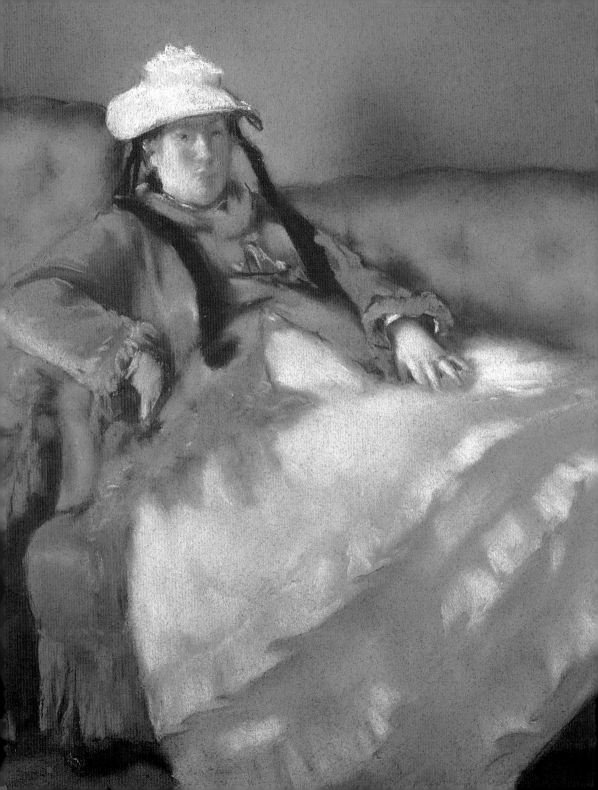

The show, in which Renoir attracted special attention, met with such extraordinary success that a month later it was moved to a larger space. That notwithstanding, as Castagnary rightly noted in his articles about the Salon, the counter-exhibition was nothing other than a surrogate of the main one, which essentially perpetuated the jury's excessive power. Though it gave the rejected paintings the chance to be seen by the public, it still branded their works as second-rate. The artist's own exclusion of a considerable number of their paintings helped the committee's cause, which, as in 1863, put the most focus on the most mediocre works. Manet's success itself became a point of discouragement. His colleagues did not consider his work up to his level, and, detected a compromise with official tastes in it. A growing number of voices rose to call for abolishment of the jury as the only way to give everyone the chance to face public opinion directly. Manet, though not yet fully

accepted, had come out of his more beleaguered phase. Thanks to Durand-Ruel, he started to see a reasonable number of sales. For example, five paintings were bought that same year, 1873, for a rather high price by Jean-Baptiste Faure, a famous baritone of the Paris opera, who would become his greatest collector, eventually coming to own sixty-seven of Manet's works. But the skies were not entirely clear for the painter, and the next year he had two paintings of the three presented to the Salon rejected.

A few months earlier he had met the poet Stéphane Mallarmé, who immediately picked up a pen in his defense, publishing a long article called "The Painting Jury of 1874 and Manet." The writer astutely exposed the hypocrisy of the committee's decisions. As they had not patently rejected all three works entered, they were trying to avoid being accused of unfairness and individual persecution. He also noted that it was just a matter of time before Manet's artistic

innovations would definitively revolutionize taste and dethrone Salon painting. He concluded, "Gaining a few years on Manet: sad politics!"

Supported by the sales made in recent months and the fairly good prices received, the other painters of the Batignolles group managed to put into practice their plan to organize an independent show. On May 15, 1874, a few months after the opening of the Salon, the first group exhibition opened in the studio of the photographer Nadar. It was all the more vital to try to build public support and attract new buyers at the time, because Durand-Ruel was in major financial trouble and had been forced to close his London branch. Though some had started to become interested in the painting of Monet and his friends, most considered them a joke, and this opinion naturally affected their dealer. In December of 1873, Monet, Renoir, Degas, Pissarro, Sisley, Berthe Morisot, and other less-known artists founded the Anonymous Society of Artists, Painters, Sculptors, Engravers, etc. Renoir had chosen the name, seeking to avoid doing critics a favor by giving the impression of having founded a new school. Though Manet had been invited to participate, he did not. Nor did he take part in any of the shows that his friends organized together. Manet's position was clearly informed by a mix of conviction and calculation, though his official reason, according to John Rewald in his book *History of Impressionism*, was that he would never let himself be mixed up with Cézanne. On the one hand, he firmly believed that any work of innovation should not reject tradition, but should rather pass through it, and he always affirmed that "the Salon is the real battlefield. It is there that we must measure ourselves." (It was Proust, as usual, who quoted this proclamation.) On the other hand, just as ten years earlier he had chosen

not to participate in the meetings of the realists at the Brasserie des Martyrs, he likely thought that taking part in a dissident action, right when he was just starting to no longer be seen as a rabble-rouser, would have terrible consequences for his image.

Precisely to avoid seeming like revolutionaries or outcasts, the future impressionists, under Degas's pressure, tried to gain as many members as possible, especially among painters who regularly exhibited at the Salon as well, such as the Italian painter Giuseppe De Nittis. As for Manet, not only did he refuse to participate, he tried to dissuade his colleagues whom he considered most talented: Degas, Renoir, Monet, and especially Berthe Morisot. At the end of 1874, Morisot (whose possible romantic relationship with Manet remains without solid evidence) married his younger brother, Eugène. Manet's predictions ended up being well-founded. The show, which exhibited 165 works, was treated at best as a joke. As

per his custom, Louis Leroy, critic of the magazine *Charivari*, published a savage attack, recounting his visit to the show in the company of an academic painter and talking about an "attack on good artistic customs," "palette-scrapings placed uniformly on a dirty canvas," and "smears of color," saying "wallpaper in its embryonic state is more finished." Even in his ill-will, Leroy correctly traced the connections between those termed the "impressionists" (from the title of a Monet painting) and the Barbizon landscape painters: "Oh Corot, Corot, what crimes are committed in your name!"

Despite his refusal to associate with them, Manet was also accurately included in the genealogy of impressionism. Discussing the simple rendering of the details in a Morisot painting, Leroy made sure to ironically emphasize that the "stupid people who are finicky about the drawing of a hand don't understand a thing about impressionism, and the great Manet would chase them out of his republic." The conceptual connection between the creator of *Olympia* and impressionism was not limited to this single sneering comment. The choice he made to not exhibit was not noticed at all and, in fact, made no difference. Manet was nonetheless considered the leader of the group by the great majority of critics, aggravated by the fact that his name was still often confused with Monet's. The reception of the only painting of his accepted to the Salon, *The Railway*, was atrocious. It would have made no difference if he had shown with his peers. The critic Jules Claretie, for one, wrote in a Belgian magazine that "Manet is one of those who would have it that in painting we can and should be satisfied with an impression." The "Manet effect" was even retroactive, going back to affect his teacher, Couture, who though he had been an artist quite esteemed in the academic realm, became, in

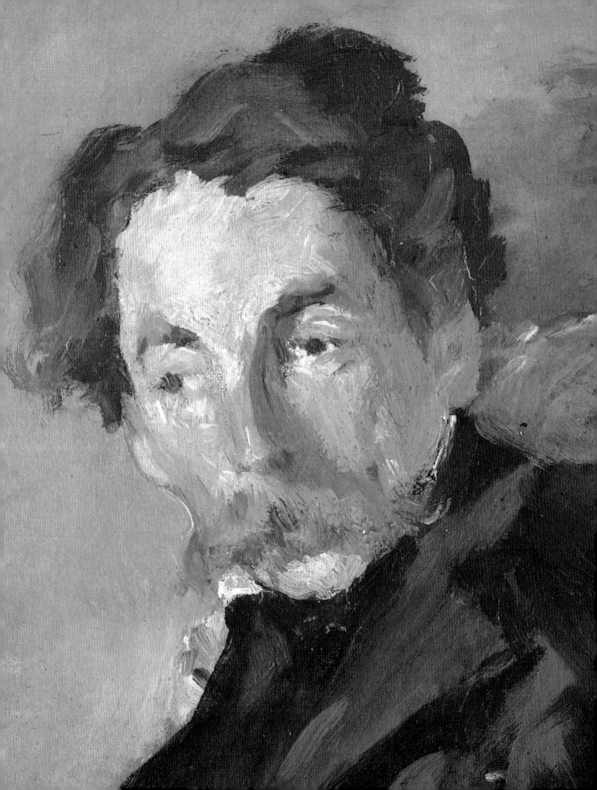

Claretie's words, the one who "taught…the art of painting in twelve lessons." According to the critic, there was now talk of a "Manet doctrine," which on the one hand involved stopping to paint "where the difficulty began" (that is, after the preparatory sketch), and on the other in making realism detestable by cloaking it with the "most distasteful frills." The most established critics had even refused to review the show, and even traditional supporters of the group, like Castagnary, did not express entirely positive opinions. Despite a few sales, in the end the exhibition was a failure, and the society had so many debts that it folded.

Though the exhibition, events turned against him, Manet did not, of course, cut off relations with his friends. On the contrary, he spent the summer in the family house across from Argenteuil, a vacation town on the Seine, near Paris, where Monet and Renoir worked.

The three painters often painted together. During the summer of 1874, Manet started to appreciate his peers' convictions. He dedicated himself to studying figures *en plein air*, immersing his subjects in full light and realistic settings, rendered with great vividness. His palette became definitively lighter, taking on brighter colors, and his execution became more lively. Nor did he begrudge his support on an important official occasion. Renoir, Monet, and Sisley, joined by Berthe Morisot, spurred by the pressing need to sell and encouraged by Daubigny's positive experience, decided to organize a public sale at the Hôtel Drouot, site of Parisian auctions. Manet wrote a letter to the influential and well-known *Le Figaro* critic, Albert Wolff, who had never expressed any favor for the young artists, asking him to talk about it in the newspaper, maintaining that in the future he would admire the new painting of light and touch. Predictably, Wolff showed no mercy. The auction was a catastrophe on

all fronts, starting with a brawl breaking out that had to be quelled by the police. The highest price, taken by Morisot, was 480 francs. Though a Monet painting reached a maximum of 325 francs, some of Renoir's pieces did not even reach 100. Manet helped his friends by exhibiting some of their works in his studio from time to time. He again presented to the Salon, with unwavering tenacity, a painting with the telling title of *Argenteuil*. The work depicted a couple outdoors, sitting against a sunny river background and was, of course, rejected. Even Zola, though rising in defense of his friend and restating his role as inspiration and leader of the Batignolles group, did not exude the enthusiasm of yore, declaring that the genius of the future had not yet been born. In 1886 Zola published his novel, *L'Œuvre (The Masterpiece)*, describing the struggles, ideas, and hardships of the impressionists, now with scant sympathy, leading Cézanne to break off a decade-long friendship with him. Manet's most steadfast supporter among writers was now Mallarmé. In May of 1875, an edition of Edgar Allan Poe's *The Raven* went to press, translated by Mallarmé, with illustrations by Manet. The collaboration continued the next year with Mallarmé's poem *L'Après-midi d'un faune*, which was accompanied by some etchings by Manet. Manet had long been interested in illustration and had made many lithographs, both independently and as illustrations. However, they did not gain any more approval than his painted work.

The next year a group, smaller than the one that had shown at Nadar's, decided to tempt fate again and organize a show that has since become known as the second impressionist show. Manet refused the invitation once again, though he was just back from a trip to Venice, where he had portrayed the lagoon, the rocking of gondolas on water, and tremu-

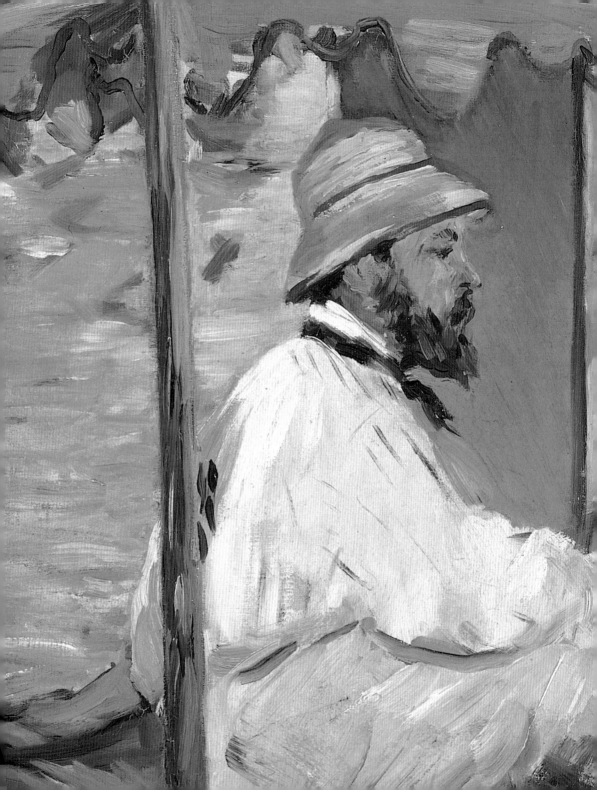

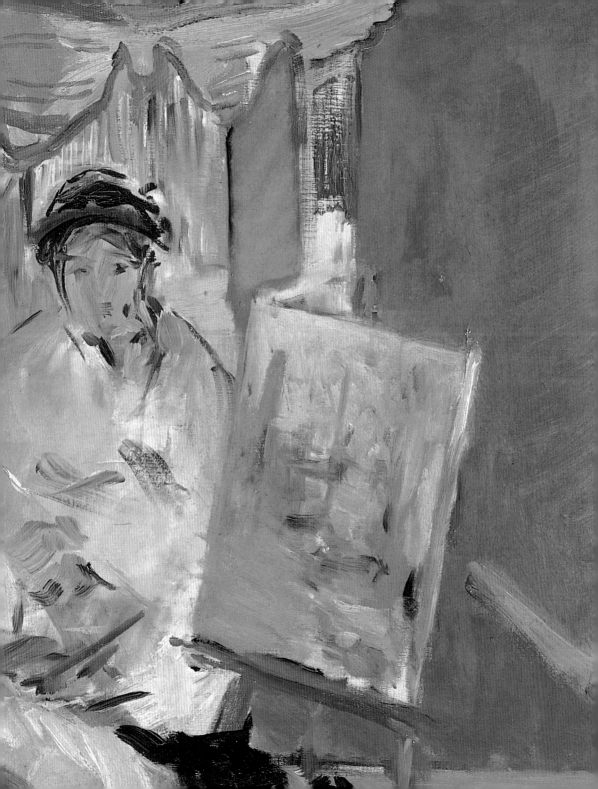

lous light in paintings of great freshness and original composition. Once again, he exposed himself with absolute tenacity and great courage to the verdict of the Salon jury. The two paintings he sent were rejected. Furious, he organized an individual show in his studio, which had thousands of visitors, accompanied by the usual publicity in the press, which dusted off the old cliché of the painter's beginnings, labeling him as a rebel and taking the opportunity to suggest that in this way he had revived his popularity in the art world of the brasseries, according to John Rewald. For his friends who exhibited this time in Durand-Ruel's gallery, things went no better. Wolff denigrated them as "five or six misfits, including a woman." Paradoxically, the paintings shown at the Salon were starting to be influenced by impressionist innovations, or rather they interpreted the luminosity and rapid brushstrokes in superficial, insipid versions. Manet was still seeking to win over the public with academic approval, and went for a diplomatic approach by painting a portrait of the critic Wolff, though the work was never completed. He also sought to cultivate relationships that could prove useful for him, like that with the painter Carolus-Duran, who had long abandoned the inconvenient credo of Courbet. Manet's ambitions were innate to his social position, which had already oriented him toward traditional aspirations and paths of success. His choices were not born of opportunism, as he continued to support Monet, including financially, since Monet was chronically afflicted by a lack of money.

In 1877 Monet's wife Camille was expecting their second child. Monet was desperate and begged Manet to find him a buyer, asking only 100 francs per painting. The price was truly a pittance, but beyond a few precocious admirers, no one was willing to buy paintings that were widely considered doodles. Manet offered his friend

1,000 francs for ten paintings, faking the role of an intermediary for an anonymous party to avoid offending Monet and thereby saving him at a highly critical moment.

In 1877, while the third impressionist show opened, Manet came up against the jury again, which accepted a portrait of the baritone Faure in costume, irreproachable at least in subject, if not in execution. But it rejected *Nanà*, another portrayal of a prostitute, inspired by the literary fiction of a Zola novel. More hard times were on the way for Manet. In the meantime, he had changed the group's meeting place from Café Guerbois to the Café de la Nouvelle Athènes; he, Degas, and Duranty were the most faithful participants, while visits by Renoir, Pissarro and Monet were occasional. By 1878 Manet was tired of submitting himself to the jury and planned to open an individual show, whose motto would be "we must be a group of a thousand or stand alone," but then he gave up on the project. What's more, the sales of his works were going poorly. The baritone Faure had to buy two of the three pieces from his own collection put on auction, and another five paintings received considerably low prices (with a maximum of 583 francs) at the bankruptcy sale of Ernest Hoschedé, a wealthy director of a large department store who had been one of the few to appreciate the work of the Batignolles artists in the 1870s.

Nonetheless, Manet, free from financial problems, did not give up on trying to win a place in the elite circle of recognized artists. To these ends, in April of 1879, he proposed a project to the prefect of the Seine for decorating the meeting hall of the municipal council in the new town hall. He planned a series of compositions representing the city's neighborhoods and "the public and commercial life of our times".

The project did not proceed. Yet, less than a month later, he has granted a meeting with the state's assistant secretary about purchasing the painting that had received the greatest success of those he exhibited at the Salon, *Le Bon Bock*. In the meantime, the annual exhibition had opened, to which newspapers and magazines, as usual, reserved set spaces, publishing a series of articles by a single commentator.

The scandal at the Salon of 1880, more than the painters, were the reviews of a young writer friend of Zola's, Joris-Karl Huysmans, who was to become one of the leading writers of decadentism. Huysmans put in a case against fashionable painters, forcefully taking the side of the impressionists, and was also one of the first to draw interesting parallels between the era's art and literature. Manet was naturally among his favorites. In 1877 he had dedicated an entire article to the painting *Nanà*. In 1879, proceeding in fits and starts, the jury had again accepted two works by Manet, *On the Boat* and

In the Conservatory, which were strongly influenced by his young colleagues, both in setting and execution. However, Manet's reception was lukewarm as usual. He had befriended a singer, Émilie Ambre, whose portrait he had painted, and took advantage of his tour in the United States to exhibit in theatre foyers to show his only painting set in the new world, *The Execution of Emperor Maximilian,* which was set in Mexico.

The American market was becoming interesting for many dealers, who were drawn by the still scarce presence of works of art and a wealth of entrepreneurs. However, in the late twentieth century, contemporary art tastes were dictated exclusively from Paris. In the United States, Manet also caused more puzzlement than approval, and the Chicago trip was cancelled.

Meanwhile, new possibilities for meeting the public had opened up in Paris, where a wealthy

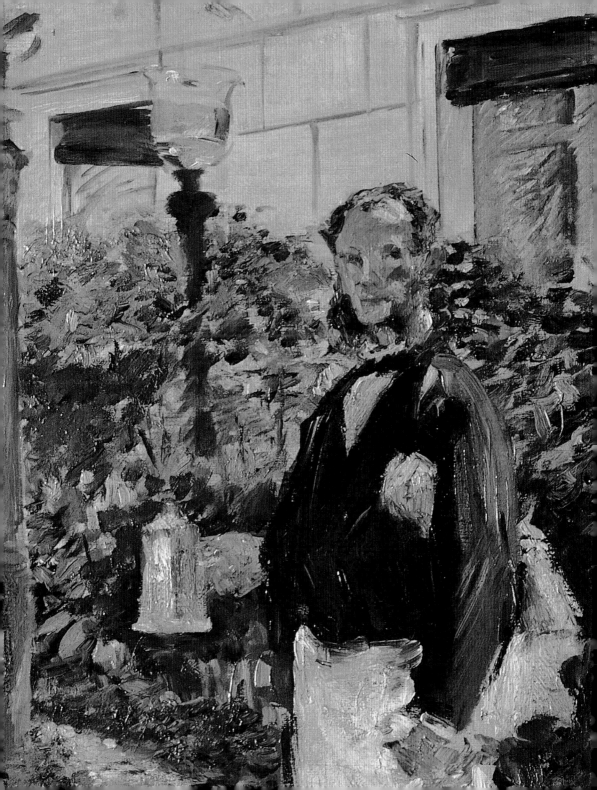

couple of collectors, Mr. and Mrs. Charpentier, had started a weekly publication with the Baudelarian title *La Vie Moderne*, and opened a like-named gallery. In April of 1880 the gallery hosted an individual show for Manet, who was also accepted at the Salon again. His health had since started to deteriorate, and rather than stop working he underwent a series of treatments. On the positive side, his position in the artistic establishment was finally gaining ground, to the extent that even Wolff, reviewing the fifth impressionist show (where Monet, Renoir, Sisley and Cézanne were absent and only Morisot and Degas remained), wrote of Degas: "Why doesn't he follow the example of Manet, who long ago separated himself from the Impressionists?" The presumed separation was only true to a certain point. In reality, Manet's style had changed over time, in contact with the ideas and painting achievements of his young friends, though his style stayed personal and could not be equated to the works of Monet et al., particularly for the continuing importance he gave to the human figure. The real difference was in the choice to never stop seeking approval through official routes, rather than through dissident shows.

Most importantly, Manet's name had now been known to the public at large since the early 1860s, and his works no longer incited the outrage they had in the past. Art lovers and critics were now used to seeing subjects taken from contemporary life. They had also become accustomed to digesting Manet's style, and the role of the revolutionary was now reserved for the younger artists, especially Paul Cézanne, who, however, unlike Manet, happily played the part of the rebel. A particularly auspicious situation was about to give a much-desired turning point in Manet's career. His long-time friend, Antonin Proust, a portrait of whom he had exhibited at the Salon of 1880, had become a member of the Chamber of Deputies.

At the end of 1881, Gambetta appointed Proust Minister of Fine Arts. The effects were immediate. Manet, who had been awarded with a mere second level medal for a portrait exhibited at the Salon that year, became a knight of the Legion of Honor. Proust even managed to have the state buy some Courbet paintings. It should be kept in mind that such actions were possible because the artistic climate was changing, and because since 1881 the Salon's jury was no longer managed by the Academy. It was run by a society of artists, which had made it possible for Manet to receive even that meager prize. However, his health was continuously deteriorating. On doctors' advice Manet spent the summer outside of Paris, writing to Astruc "the countryside has its charms only for those who are not forced to be there." Despite his appreciation for Monet and Renoir's work, Manet was a city dweller at heart. The last painting he exhibited at the Salon of 1882 was *A Bar at the Folies-Bergère*, a spontaneous portrayal of a young waitress captured in a moment of distraction in a noisy crowd with a customer in front of her.

On September 30 of the same year Manet wrote his will, designating Suzanne and Léon as his universal heirs and Théodore Duret as the will executor, with the option of selling or destroying the works kept in his studio. His strength wasted away before everyone's eyes and he was soon bedridden and paralyzed. On April 20, 1883, after his left leg was infected with gangrene, it was amputated. Ten days later, Manet died. His casket was carried by Proust, Monet, Zola (though he and Manet had grown distant over time), Duret, the painter Alfred Stevens, and the writer Philippe Burty.

The year before, when the critic Chesneau had brought Manet complements from Count Nieuwerkerke, Minister of Fine Arts in Napoleon III's time, he had responded to tell him that "it should

condemn Manet's work to scandal, as he worked with contrasting areas of light and shadow, quite different from the "niceties of artistic confections in fashion." As such, by introducing "a living canvas in that great mass grave of the Salon," Manet "offended the dignity of art." Beyond his struggle for official recognition, with the exception of his voluntary enrollment in the military when the empire fell, Manet led a life without significant events, marked almost exclusively by café meetings and, most importantly, by the annual Salons. Thanks to a substantial inheritance from his father, he was never victim of chronic financial problems like most of his friends, a situation which certainly offered him much peace of mind, as well as the opportunity to avoid compromise. His constant concern was to get official recognition for his painting, of whose quality he was convinced. On the level of style, Manet also stayed true to himself. When, under Renoir and (especially) Monet's

influence, his palette became lighter and he started to paint *plein air* figures using more vibrant and dynamic brushstrokes, he never abandoned his own expressive language, staying true to the use of black (which Manet succeeded in making amazingly brilliant), a color unheard of on the impressionist palette. These characteristics make Manet's painting a link between realism and impressionism, an absolutely unique instance, outside of any movement and fundamental for the revolutionary new course undertaken in late nineteenth-century French painting.

never disowned his upper-class roots. As shown by his choice to stay with Couture for six years, despite his disapproval of him, he had every intention of gaining success within the official art system. His determination in presenting to the Salon jury throughout his entire life, his refusal to join the group of realists, and later to exhibit with his impressionist friends, demonstrate that he was the exact opposite of a dissident or rabble-rouser. Yet Manet was well aware of his role as an innovator. He wished to mark an explicit turning point in French painting, but had no intention of doing so by disowning tradition.

By studying the masters of the Italian Renaissance and the Spanish painters of eighteenth-century, with whom he conceptually converses in his works, he put himself in continuity with his illustrious artistic predecessors. However, this did not mean copying the achievements of the great artists of the past. Rather, it meant the pursuit of a personal style by constantly drawing on this legacy, which would come to express the essence of the contemporary moment. His very choice to paint the present, along with his rejection of idealism and sentiment, transgressed Salon painting canons, especially that of pleasant decoration, in which the representation of the nude was justified by historic or mythological references.

As Zola accurately notes, in Manet's works "we have neither Gérome's *Cleopatra* in plaster, nor Dubufe's white and pink little people. Alas, all we find are everyday people, who make the mistake of being flesh and blood like the rest of us." Though staying true to his subjects made Manet a realist, he separated completely (aside from a few early paintings) from the social criticism in the works of Courbet, aligning himself instead with Baudelaire's theory of representing modern city life. His concise style also helped

have been him to decorate me. He would have given me fortune. Now it is too late to make up for twenty years of failure." He was also disappointed by the general lack of understanding with which the public and traditional critics had interpreted *A Bar at the Folies-Bergere*. He wrote ironically to Wolff, "I wouldn't mind finally reading, while I'm still alive, the wonderful article you will dedicate to me after I'm dead." The critic, however, would not have given him any satisfaction. In fact, he ended his obituary attributing to Manet only "two excellent works" worthy of the Louvre. Wolff was mistaken, and Manet's stock started to rise.

A few months after his death, a large retrospective was held at the École des Beaux-Arts (the director had actually refused to provide the spaces, but he had to relent under pressure from Proust). The studio's auction that followed the show took high (if not extraordinary) prices. The buyers were mainly the usual admirers, from Faure to Durand-Ruel and Edgar Degas. However, Manet's widespread reputation would soon solidify, as demonstrated by the case of *The Fifer*. Bought in 1872 by Durand-Ruel for 3,000 francs—high at the time for Manet— sold to Faure the next year for 7,000 francs, it was bought back by Durand-Ruel in April of 1906 for 20,000 francs, and resold less than a month afterwards for no less than 150,000 francs. "Oh, pardon me. I thought you were a giant, and I was looking everywhere for a sinister and twisted face." In his article titled "Manet at the Salon in 1866," Zola told an anecdote emblematic of the amazement of journalists who were introduced to the painter "who was sitting modestly, only taking up a tiny little space." After the scandals raised by *Le déjeuner sur l'herbe*, the religious paintings, and *Olympia*, the cliché that had formed in the public imagination had branded him as a kind of societal outcast, a tormented, and even dangerous, man. On the contrary, Manet had

The Masterpieces

Woman with Fans
(detail), 1873–1874
Paris, Musée d'Orsay

The Guitarist

1860
Oil on canvas, 147.3 × 114.3 cm
New York, The Metropolitan
Museum of Art

This painting was such an attraction at the Salon of 1861 that it was moved from its disadvantaged original placement and awarded an honorable mention, launching Manet as a rising star in French art. A premeditated act was at the foundation of the painting; Manet had seen *The Absinthe Drinker* rejected at the previous Salon in 1859. His friend Antonin Proust quotes him as saying, "I represented a Parisian fellow, painted in Paris, putting the simplicity I found in Velázquez in its execution. It was not understood. Perhaps they will understand better if I do a Spanish fellow." Spanish culture had been in fashion in France since 1840. Manet nursed a great passion for eighteenth-century Spanish painting, which he had studied and copied at the Louvre, though he had never been to Spain. Despite many critics seeing an instance of high realism in the painting's depiction, the costume was actually a picturesque studio invention. Likewise, the character portrayed was a posed model, not a real guitarist. While still painting the work, Manet discovered that he had depicted a left-handed player with a guitar tuned to be played with the right hand. All the same, a group of young realist painters were excited about the work and organized an official delegation to Manet's studio, seeing in the work "a painting that is in between what is called realist and what is called romantic," according to the critic Desnoyers. Despite the fact that the work was not factually correct, in terms of style its observation was precise. Through a quite simple layout and a brief, contrasting execution (Manet declared that he had painted the head in a mere two hours), he achieved a high impact image. He matched the dynamic, lively pose with large color swaths for the different surfaces and extraordinary details like the white handkerchief, the shoes with their worn-down soles, and the red vase.

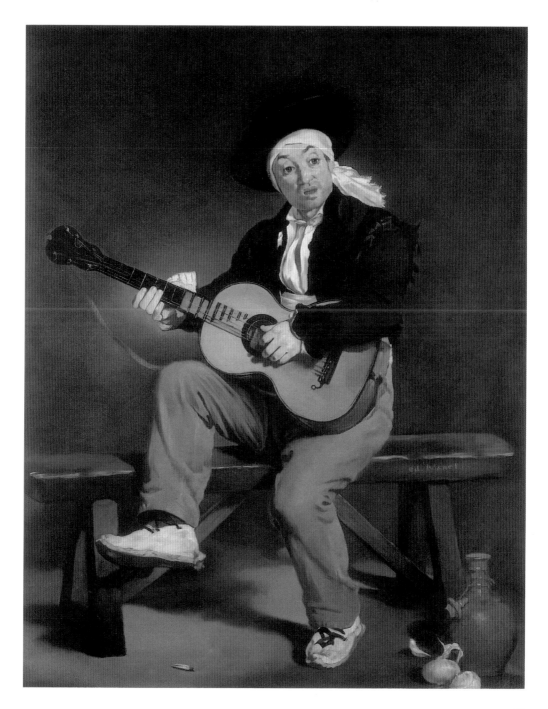

Music in the Tuileries Gardens

1862
Oil on canvas, 76 × 118 cm
London, National Gallery

The Tuileries gardens connect the Place de la Concorde to the Louvre. In Manet's day, they were a prestigious gathering place, hosting concerts that became high society events. Manet, with his upper class background, was part of this refined milieu. Its title notwithstanding, there is no hint of a musical instrument in the painting. The scene's focus are the figures crowded between the trees, their gazes, and their conversations. In addition to himself (in the foreground, to the left, with the walking stick), Manet depicted many of his friends in the painting, including his brother Eugène, the critic Astruc, painter Fantin-Latour, the wife of Commandant Lejosne, the musician Offenbach, and the poet Charles Baudelaire. Baudelaire had recently written the essay "The painter of Modern Life," later published in 1863, to which Manet's painting appears to be intended as the painted version. The painting, first exhibited in a private gallery, incited a great uproar. Manet had transferred to the sophisticated language of painting a kind of scene that was specific to the lower genre of magazine illustration, something that scandalized the public. Other disturbing factors were the rapid style, details that were barely sketched, and features which go perfectly with the sonorous impression of a busilychatting crowd. The critic Babou sharply condemned this "mania for seeing in *taches* [color patches]," extended to the portraits as well, "the tache–Baudelaire, the tache–Manet". The effect, which opened the door to modern painting, was clearly intentional; in fact, though he had made studies on site, Manet painted the work entirely in his studio. Manet had ultimately created a daring portrayal of modernity, of that Parisian life soon to be celebrated in a short work by Offenbach, with the lyrics "Everything turns, turns, turns…Everything dances, dances, dances…".

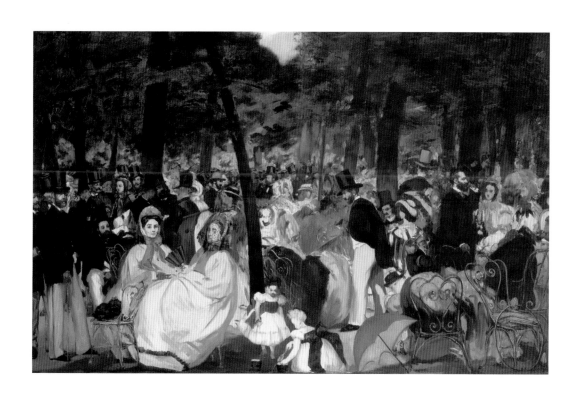

Lola de Valence

1862
Oil on canvas, 123 × 92 cm
Paris, Musée d'Orsay

After his success with *The Guitarist,* Manet again portrayed a Spanish subject, this time choosing a real person and a subject—that of the dancer—well represented in French painting. Images of Spanish dancers in particular had so much success that even the Realist painter Courbet had painted a work in 1851 that is very similar to Manet's. However, it is known for certain that Manet had never seen it, indicating that the similarities are due to the similar sources of Goya's paintings and popular prints.

Lola, dressed with the Andalusian costume in which she performed, is shown in a pose with one foot in front to the other and a closed fan in her hand, ready to go on stage. The artist's attention focused on the rendering of the dress, and her gauzy *mantilla*, decorated with red trimmings, contrasted strongly with the full skirt, so vivid in its combination of a black background and brightly colored flowers. Against the tenants of official painting, these details are not minutely rendered with a wealth of well-defined details; instead they are barely sketched through the juxtaposition of patches of color. For these reasons, the painting caused a stir when it was exhibited in 1863 at Manet's individual show at the Martinet gallery. It was deemed by Mantz, the *Gazette des Beaux-Arts* critic, a "caricature of color." The effect must have actually been even stronger because Manet repainted its original neutral background adding a hint of a set and the impression of seated audience members.

Baudelaire celebrated Lola in a quatrain, which became an immediate object of parody: "Amongst the many beauties one sees everywhere, I well understand, friends, that desire hesitates to choose/ But one sees sparkling in Lola de Valence/ The unexpected charm of a pink and black jewel," words which, in fact, poorly pair with the portrait of the rather masculine woman painted by Manet.

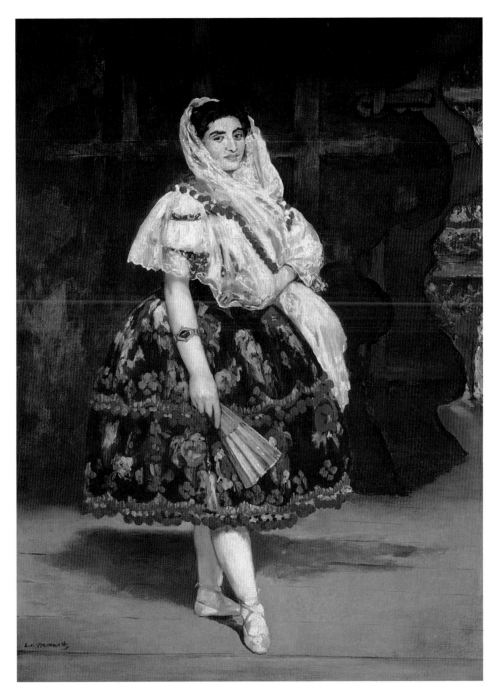

The Street Singer

c. 1862
Oil on canvas, 175 × 118.5 cm
Boston, Museum of Fine Arts

According to Proust, the idea for this studio-painted scene came from a walk in one of the Parisian neighborhoods demolished and redesigned by Baron Haussmann's new boulevards. Manet was struck by a woman who was coming out of a modest cabaret, raising her dress and holding a guitar. He asked the singer to pose for him. When she refused, he portrayed Victorine Meurent, his favorite model at the time.

To the scene of original inspiration Manet added a wonderful still life of cherries in an open paper that Victorine brings to her mouth with a weary gaze lost in thought. Beyond the green door behind her, we glimpse the smoky interior of the cabaret. The painting works with the harmony of dark earthy hues, brightened by the yellow and red of the still life and the black trim of her jacket. Manet chose to make a life-sized portrayal of a common subject, giving it the stature of an official portrait, which predictably drew fire from the critics.

Manet was accused of having lost the righteous path undertaken with *The Guitarist*. According to Mantz, the forms were lost in the "hard, sinister" painting. On the contrary, in 1867, Zola praised the "gentle, blonde" colors, admiring the work's sculptural qualities and austerity. Traditional critics were vexed by this characteristic, seeing a vulgar portrayal in the painting, unmitigated by the pathos common in such contemporary scenes. Zola astutely observed that Manet treated his figures like still lifes, paying more attention to the play of forms and colors than the soul of his characters. Indeed, Manet seemed more attracted by studying the work's formal quality, perhaps influenced by the two-dimensional figures turned into contours in Japanese prints, than its social implications.

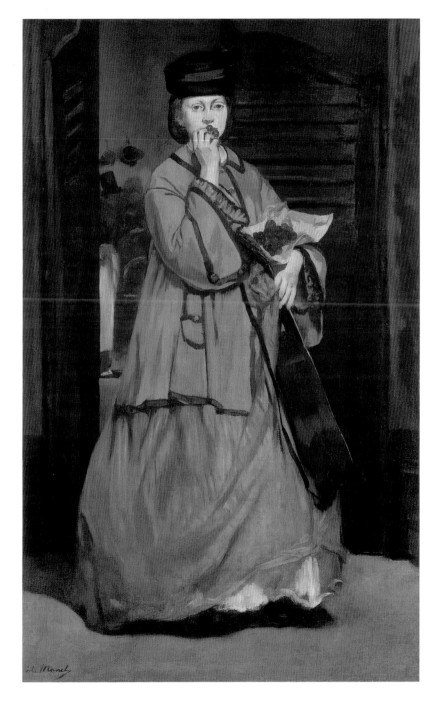

Mademoiselle V. . .
in the Costume of an Espada

1862
Oil on canvas, 165.1 × 127.6 cm
New York, The Metropolitan
Museum of Art

Manet's use of Spanish subjects was informed not only by the era's fashion, but primarily by his passion for eighteenth-century Spanish painting, and he had procured some traditional costumes that he had his models wear. Despite the semblance of realism, the painting is an explicit fiction. The title declared that the matador was impersonated by a woman instead of a man and, what's more, a Frenchwoman posing as a Spaniard. The shoes are completely unsuitable for bullfighting, and the great distance between the size and rendering of the figure in the foreground and the background gives the impression of a kind of a photomontage.

The painting was exhibited at the Salon des Refusés in 1863 and arose the now-familiar criticisms of its cursory execution. While the pink cape seems like a piece of extraordinary modernity to us today, the reviewers of the time saw it as an unfinished sketch, a judgment they applied to the entire painting. Again Manet concentrated on the work's formal qualities, orchestrating a sophisticated harmony of colors that combined the artist's characteristic brilliant—even luminous—black, with the pink, yellow, and white patches of the costume's smaller details.

Undeniably, there is a considerable disparity between the main figure, fixed in a rather rigid pose, and the background, lacking consistency in terms of perspective and spatial organization. This absence of organic qualities is not the mark of a lack of skill; it is, rather, a sign of his exclusive interest in studying and juxtaposing colored masses.

The work was purchased by the dealer Durand-Ruel in 1872 for 4,000 francs. He sold it two years later to the singer Faure for 5,000, and bought back it for twice that in 1898; at the end of the same year, the American collector Havemeyer paid 150,000 francs, and later donated the collection to the Metropolitan Museum.

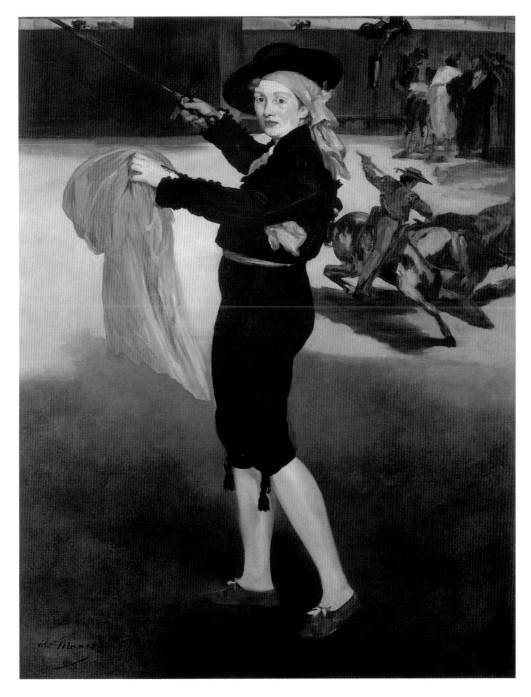

Le déjeuner sur l'herbe

1863
Oil on canvas, 208 × 264 cm
Paris, Musée d'Orsay

The nude is inevitably indecent when painted by vulgar people—or such was the scornful opinion of the English critic Hamilton about the painting exhibited at the famous and controversial Salon des Refusés in 1863.

Two men in contemporary clothes converse in a field next to a nude woman, while another nude woman is bathing in a stream. The lunch is placed between us and the nude model, who gazes openly in our direction. The painting, originally titled *The Bath*, raised a chorus of indignant, even disgusted, voices, despite Manet's having drawn on historic models. Proust tells us that the painter was inspired by an actual scene (a group of women taking a bath in the Seine), undoubtedly filtered through Giorgione and Titian's *Concert Champêtre* and a Marcantonio Raimondi engraving after Raphael's *Judgment of Paris*. The portrayal of the nude was certainly nothing new in French art. From the venerated Ingres to the Salon's celebrities, it was, in fact, a recurring theme, as well as a subject of study at the École des Beaux-Arts. The nudes of historic painters, however, though much more sensual than Manet's, were justified by being put in mythological or literary contexts. Manet's reference to great masters in *Le déjeuner* did nothing to legitimize the work, and made it seem even more scandalous, a desecration of a noble model, even sullied. Hamilton unequivocally expressed his opinion that a disgraceful Frenchman had translated Giorgione into modern realism and horrible modern French clothes in place of the elegant Venetian costume. The contemporary setting, which removed the hypocritical support of the historic guise, was unacceptable. Stylistically speaking, the work, related to Courbet's realism, was also shocking. The lack of definition to the forms, working through color alone, was considered absolutely insolent.

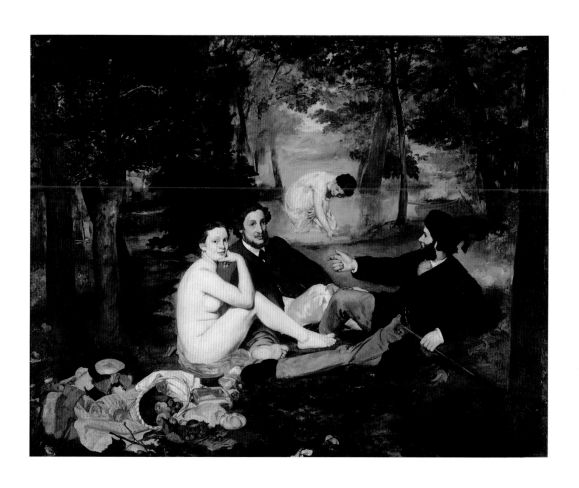

Olympia

1863
Oil on canvas, 130.5 × 190 cm
Paris, Musée d'Orsay

This painting was shown at the Salon of 1865. Normally, it would have been rejected, but the jury had become more flexible after the Salon des Refusés. The painting caused enormous scandal, condemning Manet forever to a career of endless struggle with official circles, as he was marked as a provocateur determined to insult bourgeois sensibilities. As he had in *Le déjeuner sur l'herbe,* Manet interpreted two famous sources, the Titianis *Venus of Urbino* and Goya's *La Maja desnuda*, similarly transgressing them. Again there was a lack of any kind of idealization, and, moreover, no room for doubt about the protagonist's identity. "She has the grave flaw of looking like many young ladies you know. Then, there's his strange obsession with painting differently than others! If Manet had at least borrowed a powder puff from Cabanel…". Émile Zola summed up in these three lines *Olympia*'s potential for scandal, a subject taken from modern life without any historic costume, executed with an innovative style, rejecting the mawkishness of fashionable painting. The comparison to Cabanel is particularly fitting because he had triumphed in 1863 with a sensual reclining nude, *The Birth of Venus*. Nothing in Manet's painting let one doubt that the subject is a prostitute, from her name (common at the time) to her courtesan's slippers. Unlike the heroines of past paintings, Olympia stares at us unsmiling, erasing the idea of the slightest romantic image or sense of mystery. Though the presence of the black attendant was also nothing new, here she could not be taken for a harem slave, as in many paintings with exotic subjects. Manet had made use of a rough execution, building the work on contrasting light and dark areas; though considered brutal at the time, it is this very highly refined juxtaposition of color and its sculptural concision that make the work a masterpiece.

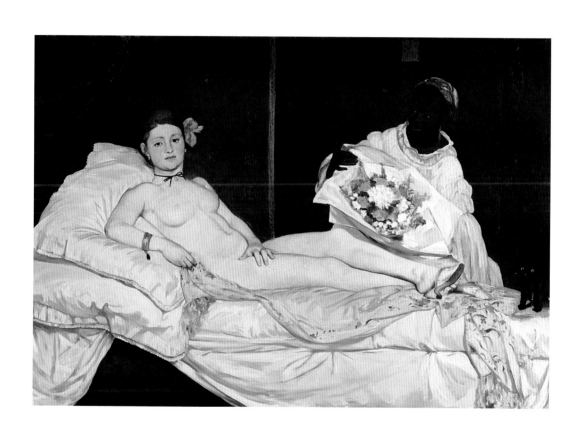

Dead Christ and the Angels

1864
Oil on canvas, 179 × 150 cm
New York, The Metropolitan
Museum of Art

This large painting was exhibited at the Salon of 1864, where it succeeded in raising another furor. Manet seemed to be deliberately trying to break every bourgeois taboo. This time, more than the subject itself, it was the execution and the choice of the colors that inflamed sensibilities. The dirty white of the cloth on which Christ is laying comes up against the body's shadowy pink, which many critics interpreted as mere dirt. The realism of the dead body seemed like open blasphemy, a caricature of all that is holy, which took no consideration of the spiritual aspect of the Savior's death. Moreover, the *Life of Jesus* by Ernest Renan had been published the year before, in which the author suggested seeing the supernatural events narrated in the Gospels as fully explicable episodes. Though it is unknown whether Manet read the book, which had, of course, raised much controversy, the painting was immediately tied to the written work. It is also possible that the painting was an indirect response to the theories of Gustave Courbet, the leader of the realist school. At the end of 1861 he had addressed a well-known open letter to some students of the École des Beaux-Arts, urging them to depict only visible subjects. Courbet declared that painting is a tangible art and should therefore dedicate itself to the existing world, so abstract and imagined things lie outside its province. Several writers reported Courbet's sarcastic comments about the painting, of which he especially criticized the angels, with their colored wings and human aspect. Manet was certainly not in agreement with this colleague, yet it is unlikely that this was the painting's origin. Manet continued to profess unflappable faith in the painting of great Italian and Spanish masters, which he had studied and copied in person in his travels. The *Dead Christ* is another tribute to, and free interpretation of, the works of Mantegna, Veronese, and Tintoretto.

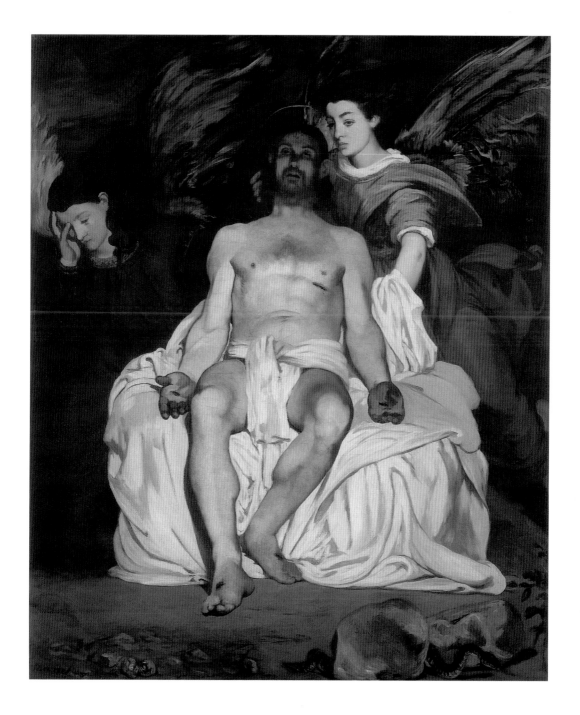

Dead Toreador

1864–1865 (?)
Oil on canvas, 75.9 × 153.3 cm
Washington, National Gallery
of Art

The painting's unusual, long and low size was a result of Manet having cut the toreador from an original, larger composition depicting a bullfight. The full work was shown at the Salon of 1864, inspiring the derision of the public and critics for its lack of spatial coherence and the disproportion between the figure in the foreground, a small central bull, and three larger toreadors in the background. Several satirical vignettes parodied the work. In one of them, the toreador was shown as a little wooden soldier. It may be that Manet himself was not satisfied with the painting, considering that he ended up dividing it and reworking it. The three background toreadors would al-

so become an independent work (New York, Frick Collection). The figure does seem to float in dark space, without any kind of connotation, anchored to the space only through small shadows.

The execution and color choice, however, are extraordinary. The white and pink variations of the cape, the socks, the waistband and shirt are particularly luminous, and contrast with Manet's characteristic brilliant black. The light-colored fabrics have a silky appearance achieved through highly effective, fluid brushstrokes. The painting's

qualities were soon recognized. In 1868 it was awarded a silver medal in an exhibition at The Hague. Henri Matisse considered the work in an egual level with works by Rembrandt and Rubens, between which it was hung in a private collection in Philadelphia. Clearly, in its style even more than its Spanish subject, Manet sought to evoke the painting of the greatly-admired Velázquez, whose intense simplicity and harmony of earthy colors illuminated by light patches are echoed here.

Vase of Peonies on a Pedestal

1864
Oil on canvas, 93.2 × 70.2 cm
Paris, Musée d'Orsay

Though Manet often included still life passages within his paintings, in only two periods of his life did he dedicate works exclusively to them, in 1864–1865 and in the early 1880s, when his deteriorating health prevented him from working on more ambitious compositions. The fairly large painting in the Musée d'Orsay shows a small decorated ceramic vase, typical of the reign of Napoleon III, with a bouquet of pink and dark red flowers, explosions of light, and luminous color in the midst of the dark green shapes of the leaves. A stem has fallen on the table, on which a pile of pink petals also lies. Several critics said that Manet was drawing on the *vanitas* tradition of representing the frailty of beauty, which is inevitably destined to wilt. The splendid bouquet, which expands in all directions, stands out powerfully from the dark, homogenous background with the tone of its color and the vivacity of its execution.

The floral still life was a quite popular genre; Fantin-Latour, Degas, Monet, and Renoir, painted many of them in their early years. However, Manet's stood out from them, defined particularly by the choice of flowers with large corollas and fleshy petals that filled the entire painted surface with a few branches. At the time, peonies were a fashionable flower, recently imported from the East. Manet dedicated an entire series of paintings to them.

When Vincent van Gogh moved to Paris and started to paint floral still lifes he was struck by Manet's painting, in which he admired the refined chromatic contrasts and thick brushstrokes.

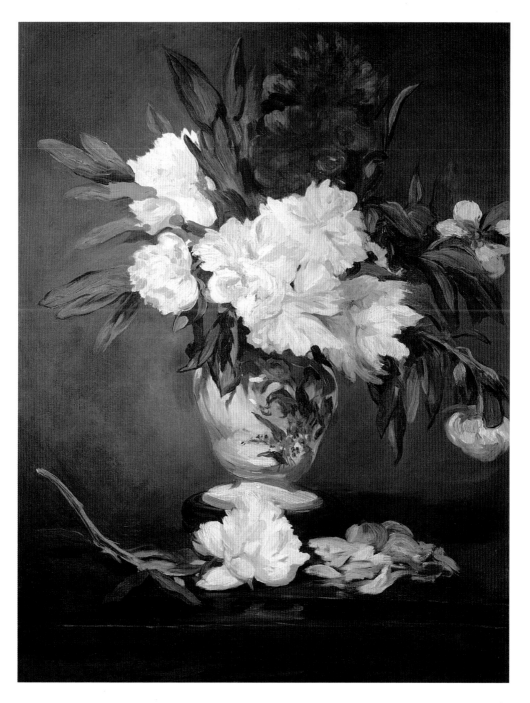

Branch of White Peonies
with Pruning Shears

1864 (?)

Oil on canvas, 31 × 46.5 cm

Paris, Musée d'Orsay

This small painting is part of a group of other splendid still lifes with intimate atmospheres, conceived as presents or *divertissements*, including *The Asparagus* and *Bouquet of Violets* painted for Berthe Morisot.

Manet was a specialist in still lifes despite having painted few as independent works. He preferred to include them in larger compositions, though giving them considerable importance and space, as in the bouquet of flowers in *Olympia* and the remains of the lunch in *Le déjeuner sur l'herbe*. The still life genre had an illustrious tradition in France, particularly owing to the works by the great nineteenth-century painter Jean-Baptiste-Siméon Chardin, in which objects lived with a true poetry. Manet found the same felicitous tone and painted images full of grace, especially in his smallest paintings. Paying his habitual close attention to the juxtaposition of colors, Manet chose a black and brown background, darker than that for the vase of flowers from the same period. Against this background the two intensely luminous white peonies stand out with extraordinary power. Manet did not paint the petals naturalistically, using instead thick brushstrokes to render the idea of the flowers' hazy, soft mass. Delicate shadows of blues, yellows, and grays help create the impression of volume. To balance the color harmonies Manet included a few green leaves, almost as if they were randomly.

Manet placed the work to his friend Champfleury, a critic and realist novelist. Subsequently, in 1899, Count Isaac de Camondo bought it for 1,627 francs, a considerable amount for such a small painting; he donated it to the Louvre in 1908.

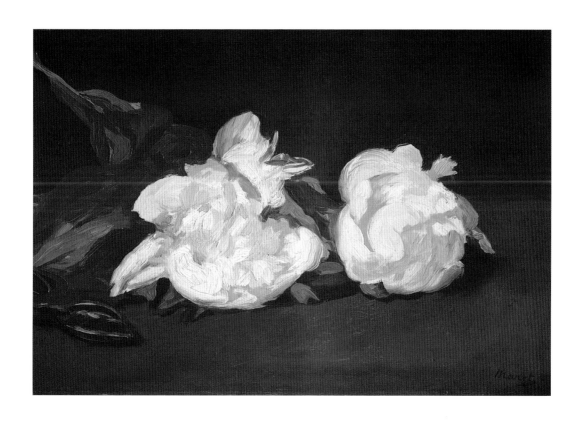

Fruit on a Table

1864
Oil on canvas, 45 × 73.5 cm
Paris, Musée d'Orsay

During the Second Empire in France fruit still lifes were very much in fashion. Their medium proportions, and especially their unchallenging nature as pleasant decoration, made them well suited to adorn noble and upper class homes. Artists drew particularly from works by Chardin, whose simplicity and natural elegance made him admired in the late nineteenth century. Manet's paintings were set apart from the paintings in fashion by his choice of materials, which were plainer than the precious painted porcelains that often appeared in the Salon artists' works. He was more interested in the general effect, the study of colored masses, the play of light, and the sculptural construction of objects through color.

His friend Philippe Burty recounts the story of a lesson on still life that Manet gave his only student, the Spanish painter Eva Gonzales: "Don't look too much at the background. Think mainly of the values." Manet wanted to show the public what he perceived, using the word "impression" to these ends, continuing, "And the grape! Do you want to count every single grape? Certainly not! What matters is the tone of the light amber and the dust that shapes them and softens them at the same time. It is the luminosity of the tablecloth…".

This work faithfully respects Manet's precepts. The dark background is clearly quite rapidly painted, and contrasts with the tablecloth's white surface, which covers the canvas's entire surface, even giving the impression of continuing beyond the frame. The scene's rhythm is marked by the effect of the folds, rendered vibrant by a dynamic light that generates small pockets of shadow. Manet harmonizes the depiction with varying tones of green, introducing the vibrant note of the peaches, and two particularly luminous reflective objects, the glass and silver knife, to fill the empty space on the right.

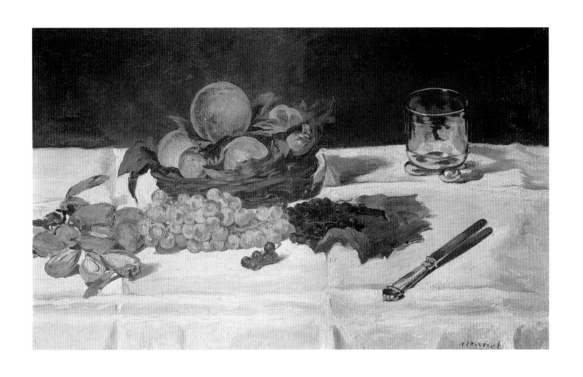

Christat Mocked

1865
Oil on canvas, 191.5 × 148.3 cm
Chicago, The Art Institute

Continuing undeterred on his path and ignoring the harsh criticism of *Dead Christ and the Angels* exhibited the previous year, Manet made another painting with a religious subject, presenting it to the Salon in 1865, where it was accepted, along with *Olympia*, surely for the sole purpose of avoiding another Salon des Refusés.

The critics' reaction was identical to that of 1864, and the work was branded as "inconceivable vulgarity." Moreover, Manet had again presented each of the elements that had fueled the negative reviews, such as excessive realism and a total lack of idealization. Christ looks more human and mortal than ever, powerless in the face of his executioners. The choice to exhibit the most holy figure of the Western world together with a depiction of a prostitute only added fuel to the fire of scandal, giving Manet the sudden and unwanted notoriety as an ignoble artist. According to his friend Duret, people turned around in the street to stare at him. Moreover, the Salons were an event visited by thousands of people of all sorts and reviewed in all the newspapers. At any rate, as he had for *Olympia*, Manet took inspiration from paintings of earlier centuries, especially the Dutch painter Anthony Van Dyck, and likely Titian as well, though his execution still was influenced, as always, by Velázquez. The figure of Christ, semi-nude and bound in the center of the composition, is surrounded by three soldiers. Manet removed all details of setting—including only a small still life—to concentrate the scene on the figures, arranged on two crossing diagonals, lingering on the description (though in his usual quick manner) of the details of the clothing, the shirt with the rolled up cuffs of the kneeling figure, the metal helmet of the older man, and the fur worn by the man standing to the right. This man, rather than Jesus, gazes at the viewer, soliciting their emotional participation.

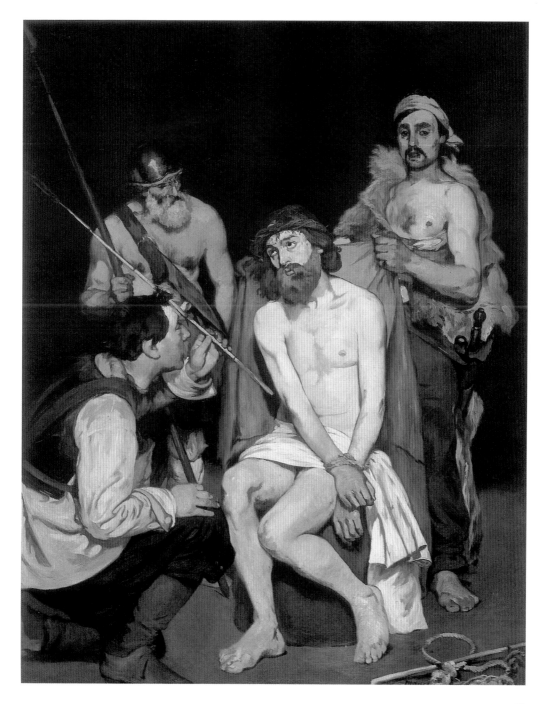

Reading

1865–1873 (?)
Oil on canvas, 61 × 74 cm
Paris, Musée d'Orsay

In 1863 Manet married the Dutch piano teacher, Suzanne Leenhoff, who was just past thirty at the time. He had been living with her since 1860, after meeting her in 1849. Manet depicted his wife here with a lightweight, gauzy dress of white muslin, sitting on a sofa of the same color. A balcony can be glimpsed through the similarly white and transparent curtains.

Two years earlier, the American painter James McNeill Whistler, a friend of Fantin-Latour, had joined Manet in creating scandal at the Salon des Refusés with a painting depicting a standing girl, known thereafter as the *Symphony in White* (Washington, National Gallery). It is unknown whether Manet sought to pay tribute to his colleague with this painting. Yet, it is likely that he thought of Whistler's portrait in orchestrating the portrayal of his wife. In 1852, Suzanne had had a son, Léon, who lived with them both, but bore his mother's last name and called Manet, whose paternity has never been verified, his stepfather.

The difference in style between the two figures in this painting give the impression that Manet returned to the painting at a later time, introducing the figure of Léon reading, and probably the plant on the left to balance the dark mass. The dynamic, vibrant execution and the luminosity emanating from the painting make it one of the examples most precociously close to impressionism. Manet constructed his wife's face with minute attention and uncommon detail, but he created its volume through shading, separating it from the rest of the body with the black necklace. An earring, almost invisible amidst the strands of hair fallen loose from the bun, helps frame her face, while the plant's leaves seem to replicate the pose of her right hand relaxed on the sofa's armrest.

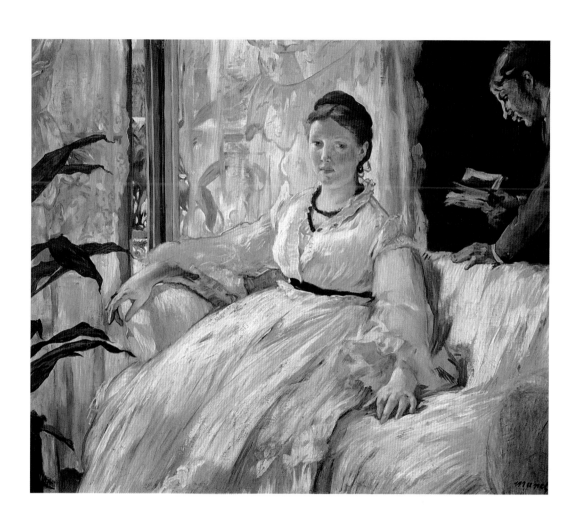

Angelina

1865
Oil on canvas, 92 × 72 cm
Paris, Musée d'Orsay

In 1865 Manet, worn down by the torrent of scandalized criticism sparked by *Olympia*, took a trip to Spain. Since his earliest years he had been a great admirer of Spanish painting, especially that of the great eighteenth-century artist Diego Velázquez, as well as the tormented painter Francisco Goya, who lived between the eighteenth and nineteenth centuries. He had painted several scenes connected to bullfighting (without ever having seen one) and folk figures, such as *The Guitarist* and *Lola de Valence*. The final encounter with reality could not help but disappoint him. Manet realized that he had inevitably idealized the land of his heroes to the detriment of France. Though he continued to admire the concise style of the two painters, he would abandon Spain as a repertoire of images, and dedicate himself to portraying modern Parisian life.

Angelina, whose very name directly evokes his favored country, was perhaps the last painting with an openly Spanish subject. The girl, who is young but not beautiful, adorned with the traditional black veil, is shown in half bust, standing behind a wrought iron railing, likely an early hint of what Manet would develop a few years later with *The Balcony*. She looks sideways out of the painting, holding a fancy black fan in her hand, an attribute which would later be given almost exclusively to Berthe Morisot. The painting's execution, as well as the color range, are clear tributes to Velázquez. The painting has a neutral background and is based on brown hues, lightened by the yellow curtain to the right, a solution often found in Velázquez's paintings. The impression of the Spanish painter's works must have been particularly strong in Manet after his recent visit to the Prado, which houses the most important Velázquez collection.

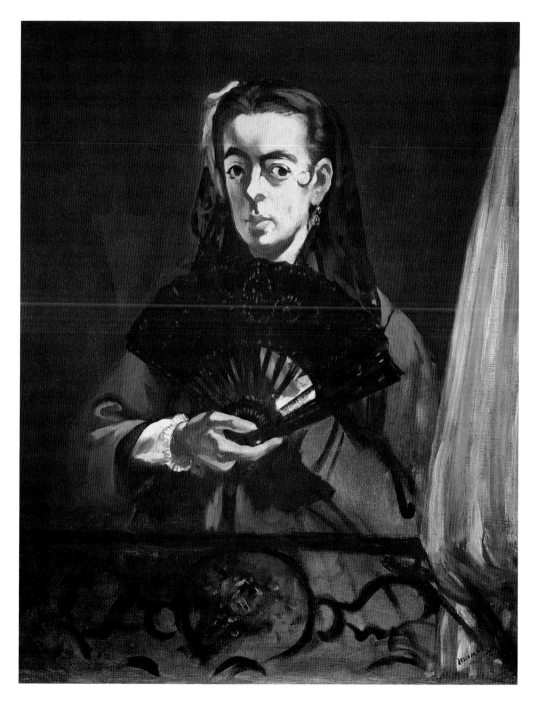

97

Portrait of Zacharie Astruc

1866
Oil on canvas, 90 × 116 cm
Bremen, Kunsthalle

Zacharie Astruc was Manet's first supporter in his early career. Though later he became a fairly successful sculptor, in the 1860s he was mainly a writer and critic who had the courage and conviction to go completely against the tide at a time when Manet was getting nothing but censure. Astruc was a passionate connoisseur of Spain and Japan, and he planned Manet's 1865 travel itinerary through the land of Velázquez.

The portrait is organized on the contrast between juxtaposed luminous and dark areas. Astruc is depicted in a formal pose, seated with a hand inserted in his elegant vest. The other hand, resting on the chair's armrest, is barely sketched, with the intentional effect of an out of focus object that goes unobserved at first glance to let the face be perceived before it. On the table, covered by a piece of cloth that picks up the color of his belt, tools are spread out that identify the craft and passions of the depicted person, as was a common historical practice. In a carefully planned jumble, Manet painted both old and new books, including a Japanese album on prominent display with its black cover. The round form and warm color of a lemon cut in half and partly peeled, taken from Dutch paintings that Manet had admired in Amsterdam, enlivens the otherwise sober composition. Historians have long puzzled over the domestic scene, discarding the theories that it could be a second room or a reflection in a mirror. It is more likely that Manet showed a painting resting on the table's edge, in which his friend's wife is portrayed. The position of the female figure, the curtain, and the plant all clearly evoke Titian's *Venus of Urbino*, which served as a model for constructing *Olympia*, whose creation Astruc followed closely.

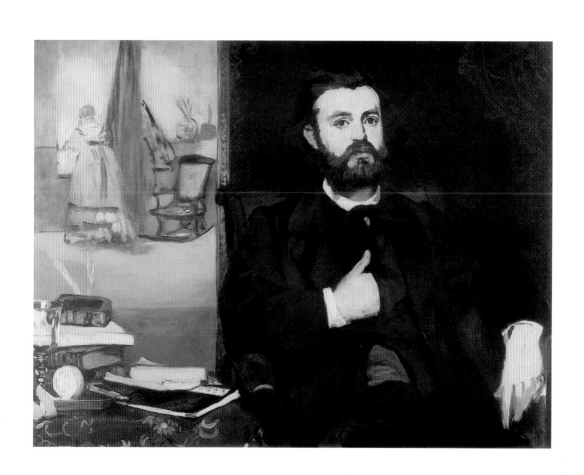

Woman with a Parrot

1866
Oil on canvas, 185 × 128 cm
New York, The Metropolitan
Museum of Art

In 1866 Gustave Courbet, in response to *Olympia*, painted a reclined female nude with a parrot flying from his perch to the raised arm of the protagonist. Manet's subsequent painting was, without a doubt, a counter response to Courbet's. The two painters' work had many points in common stylistically speaking. However, there was an open challenge between the two, both bearing the stature of the head of a school, yet very different as people.

The painting was shown at Manet's individual show in 1867, put on in response to the lack of an invitation to the Universal Exhibition and was accepted to the Salon of 1868. Critics had not forgiven Manet for the scandal two years earlier, and attacked the painting, calling the head "flat and ugly" and the effect of the pink of her skin and clothes a failure. Théophile Gautier, in particular, succinctly summed up the failures of the painting from the perspective of academic conventions: "When a painting has no composition, nor drama, nor poetry, the execution must be perfect, and this is not the case here." On the contrary, what is interesting about the painting is the very simplicity of its layout, contrasted with a delicate symphony of colors. The painting works with a refined contrast between the large pink area of the ample dress and the pearly gray of the background, which taken up again and varied in the parrot's plumage. Manet proved himself an unsurpassed specialist in tone-on-tone textures, modulating the different shades with exceptional skill. The rich color mixture of the pink, veined with gray, stands out through the break of the white cuffs, the necklace and pendant, the lilac ribbon in her hair, and the black tip of her shoe. A third note is introduced by the yellow of the perch's base, which is reflected in the animal's glass of water, along with a peeled lemon, which also appeared in Astruc's portrait of the same year.

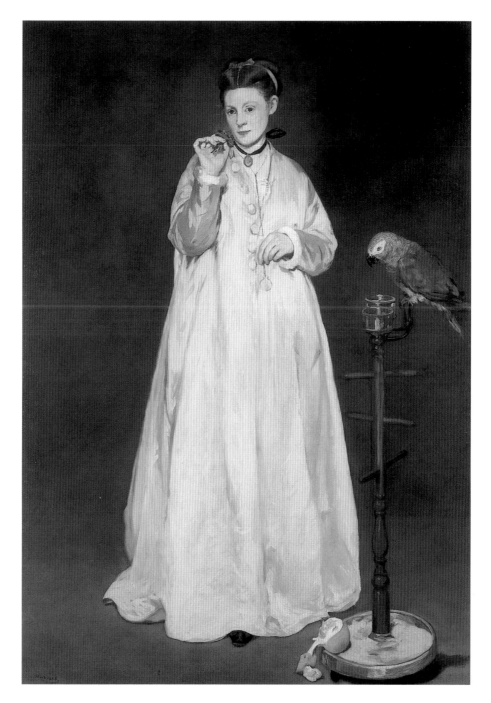

Le Fifre (The Fifer)

1866
Oil on canvas, 160 × 98 cm
Paris, Musée d'Orsay

To calm the waters after the scandal of the previous year caused by *Olympia* and *Christ Mocked*, Manet painted two single standing figures for the new Salon: a portrait of the dramatic actor Rouvière and *Le Fifre*, the image of a little chamber boy with an imperious gaze, a model whom his friend Commandant Lejosne had found him. Despite this conciliatory move, the very name of Manet now arose the horror of the jury members, who automatically rejected the two paintings. Marking the beginning of a long friendship, the young Émile Zola wrote an enthusiastic review of the painting, whose character clearly had much in common with what Zola presented in his writing. "I do not believe it possible to get a more powerful effect with less straightforward means."

Here Manet took stock of what he had learned on his trip to Spain a few months before, where he had especially admired the portrait of an actor by his idol, Velázquez, to which *Le Fifre* is a clear tribute.

Doing away with all details, Manet concentrated on the figure of the little boy depicted against a neutral background. The strong contrast between the three main colors—red, black, and white—dominate the image, painted with a flat execution. Its intentional two-dimensionality is accentuated by the black border that encloses every form. This stylistic quality, with its intense modernity, must have further disturbed the minds of the jury, which was dominated by classicist painters such as Cabanel and Meissonier. In 1884 as well, through Mantz, official critics would deplore the lack of setting and the neutrality of the background: "no land, no air, no perspective," as well as the flat contour, handled like a playing card illustration, creating "an amusing example of a still Barbarian imagery." As he had done before, Manet elevated a subject from a genre piece to the dignity and size of an official portrait, turning it into a modern icon.

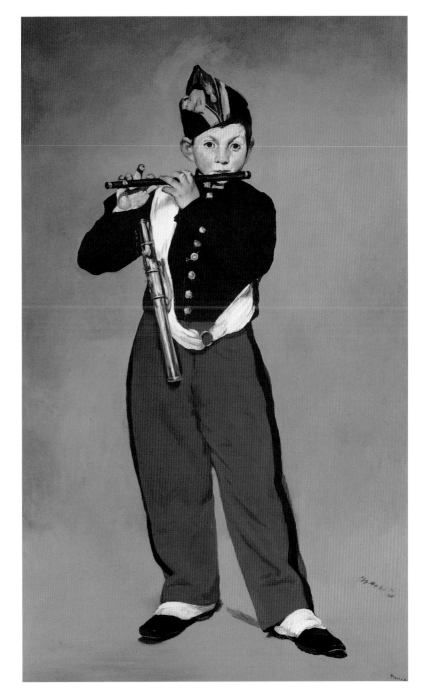

Races at Longchamp

1867 (?)
Oil on canvas, 43.9 × 84.5 cm
Chicago, The Art Institute

A more modern subject is unimaginable. Horseracing was a pastime typical of Parisian society and an absolutely contemporary amusement in its speed and fleetingness. The races were held at the Bois de Boulogne outside Paris and were frequented by a young Edgar Degas, whose bourgeois background was on par with Manet's. Degas dedicated a series of paintings to these high society events and horses. But this work, now in Chicago, is the first painted representation of a race captured at the moment of the highest energy. Though there were, in fact many, quite common English images, Manet's painting was completely revolutionary.

Rather than show the racehorses in profile, Manet framed them frontally, positioning himself conceptually in the middle of the track. Everything seems to take place in a second; the arrival of the horses that raise a cloud of dust, the clouds that pass in the sky, the sounds of the animals and crowd. Choosing to extend the fence to the painting's edge and cutting the onlookers with the frame gives the impression of being present at the event, positioned to the side of the field, behind the woman with the umbrella. Returning to the idea of *Music in the Tuileries Gardens*, bolstered by the naturally dynamic character of the chosen subject, Manet portrays a noisy, bustling — even frenetic—scene.

The unique composition drew on an idea from 1864, and the dating of the work remains inexact. Given the fairly small size and extremely rapid execution, it is likely that the painting was an early study for a work of a larger size, which met with the same fate as the *Bullfight* from which the fragment of the *Dead Toreador* came.

The Execution of Emperor Maximilian

1868
Oil on canvas, 252 × 305 cm
Mannheim, Kunsthalle

On only two occasions did Manet foray into historic painting, and each time he chose to depict scenes of great current relevance: an episode of the American Civil War that took place in France (*The Battle Between the Kearsarge and the Alabama*, 1864), and the shooting execution in 1867 in Mexico of Maximilian of Austria, who had become emperor of Mexico that year. The event was experienced with particular indignation in Manet's country because it had been Napoleon III to place Maximilian on the throne and then pull out the French troops meant to defend him. The artist, who was a faithful Republican and personally experienced injustice in the continuous rejection from official exhibitions, sponsored by the Emperor, worked on the subject for an entire year, making four different paintings, drawing on several journalistic accounts.

He again took inspiration for its composition from a past master, the Spaniard Francisco Goya, who had portrayed *The Third of May, 1808: The Execution of the Defenders of Madrid* (Madrid, Museo del Prado) in 1814. He borrowed from Goya the lateral perspective and the protagonist's white shirt, but took away the dramatic charge of Goya's work. The monumental canvas's center is taken up by a group of soldiers intent on shooting. One soldier is to the far right, emotionlessly checking his jammed rifle. In the opposite corner, the figure of the emperor is set, flanked by two Mexican general, calm and inexpressive, who were executed with him. Past the wall that serves as the backdrop for the shooting, a group of onlookers is depicted in Goya's style, watching the event with curiosity. The choice to set the event on a sunny day that brightens the verdant landscape glimpsed past the wall makes it a unique sight, far from the tragic night represented by Goya.

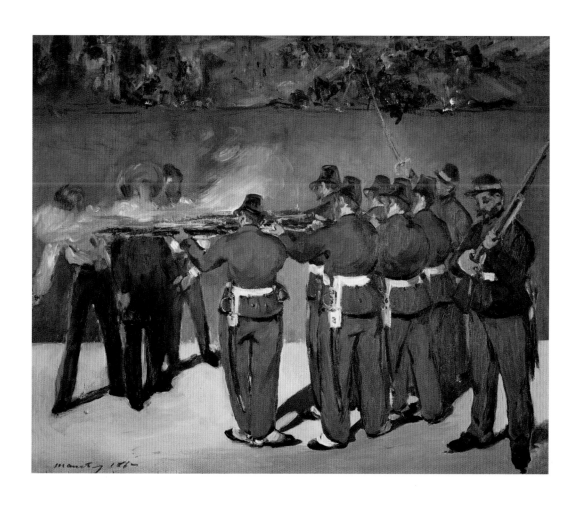

Portrait of Émile Zola

1868
Oil on canvas, 146 × 114 cm
Paris, Musée d'Orsay

In 1866, when Zola took up his pen to protest against Manet's exclusion from the Salon, writing in his column in the *L'Événement* that "Manet's place in the Louvre is secured, as is Courbet's," he lost his job. In exchange, a great friendship immediately sprung up between the two, cemented by shared intents defined by coherence to a sober yet vigorous truth. The next year Zola published a biographical and critical study of Manet. Manet decided to paint his portrait to thank his friend, emphasize their common struggle, and to make a work that would be acceptable to the Salon. Zola is captured in a three-quarter profile with an open book in his hand and a thoughtful yet determined gaze. Spread around him are the objects of the two men's shared passions, which make the painting a statement of intent, if not a full-fledged manifesto. One of the volumes stacked on the table prominently displays Zola's work about Manet, topped by a reproduction of *Olympia*, which Zola had vigorously defended. Behind it we can see an engraving of a work by Velázquez next to a Japanese print. Zola's bearded face stands out forcefully against his jacket and the black background; the space is closed to the left by a Japanese partition. Manet uses a flat execution, juxtaposing the areas of different colors without hierarchy, again inciting the disapproval of critics for painting in patches. Despite the rapid look of the execution, Manet worked with great accuracy. Zola told of how he could not get out of the pose even when his friend was painting a secondary detail because he refused to invent anything, declaring that he could not do anything without nature. The critic Théophile Gautier, who nonetheless continued to oppose him, recognized that the painting made Manet the new leader of realism.

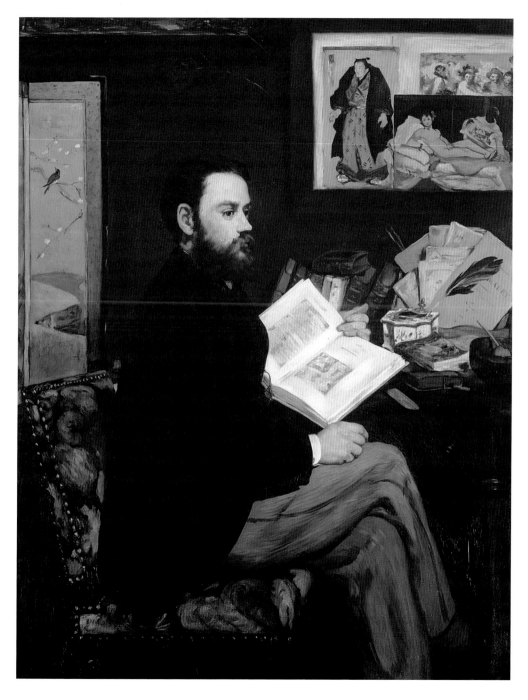

Portrait of Théodore Duret

1868
Oil on canvas, 43 × 35 cm
Paris, Musée du Petit Palais

Théodore Duret was a cognac trader with a talent for writing. In 1878 he published a book on the history of impressionist painters, the first overall work about the movement. He had met Manet by chance in 1865, in a restaurant in Madrid where Manet had verbally attacked him, taking him for one of *Olympia*'s detractors. Despite that incident and the fact that Duret was not at first completely sure of the art of his fellow Frenchman, a strong friendship arose between the two, to the extent that Manet entrusted his paintings to him during the war of 1870 and made him executor of his will.

Duret is portrayed in a small painting, standing, elegantly dressed, and holding a glove in hand, like the true dandy that Manet considered him. The future writer told of how, when the portrait was completed, Manet decided to add the stool to the right, painting the red cushion, carafe, glass, lemon, and light blue book fallen to the ground to add a note of color to the general gray tone, which he felt was too lifeless.

With the idea of making his bourgeois acquaintances admit the value of Manet's painting by the effect of surprise, Duret suggested the artist sign it in a dark corner. He would introduce the work as a creation of a fashionable painter and then declare its real maker, thus breaking down prejudices. Manet followed his suggestion to a degree, making his signature upside down, and therefore hard to read. The signature is placed by the tip of the walking stick and Duret seems to be polemically indicating his friend's identity.

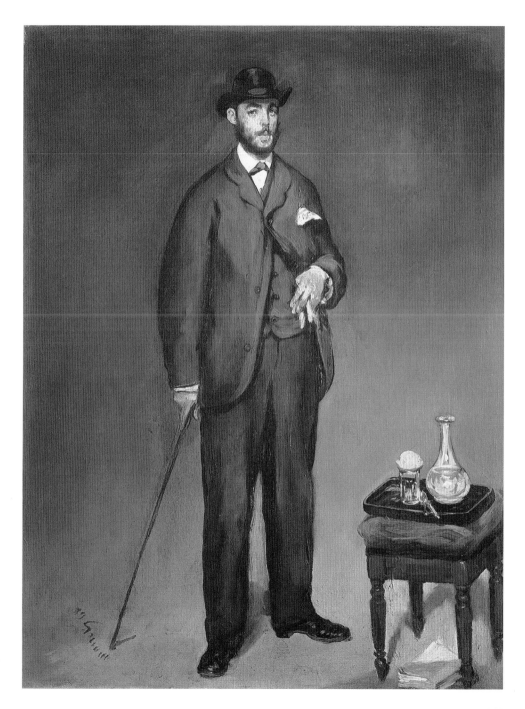

Luncheon in the Studio

1868
Oil on canvas, 118 × 153 cm
Munich, Neue Pinakothek

This painting is one of Manet's more elaborate compositions. It underwent considerable redefinition, recently exposed by radiograph. Originally the luncheon was set in Manet's studio, which could be identified by the glass pane in the background. This was later turned into a wall. Only the arms and Orientalist ornaments explain the title, though they were not even part of Manet's equipment.

The work represents the end of a luncheon, for which a neighbor posed, who is seen smoking intently to the right. A maid arrives bringing a coffee pot; the protagonist, however, is Léon Leenhoff, Manet's son or stepson. In addition to being in the foreground, the boy is the only figure in focus, depicted in a new, daring style, standing, but with his legs truncated. The still life of objects to the left, along with the plant in the large decorated vase, is a complementary pairing for the still life on the table with the remains of the meal. The latter theme is clearly taken from Dutch painting, specifically from Vermeer' s scenes, of which we again see the peeled lemon, a theme that seems to have greatly interested Manet, as he depicted it on many other occasions as well. The painting's different components are unified by its fluid and powerful execution, making use, as per his habit, of tone-on-tone variations, the whites of the tablecloth, the cup of coffee in the middle ground and the figure of the maid, all worked on a scale of grays and whites.

Renoir and Monet also painted luncheons in this same period, but their style and character were vastly different. In Manet's painting, cool tones, blues, and greens dominate, giving it a feel of alienation. Though the work is absolutely modern, it cannot be understood without Dutch painting and Velázquez's work, a constant difference between Manet and the impressionists, who never drew on past models.

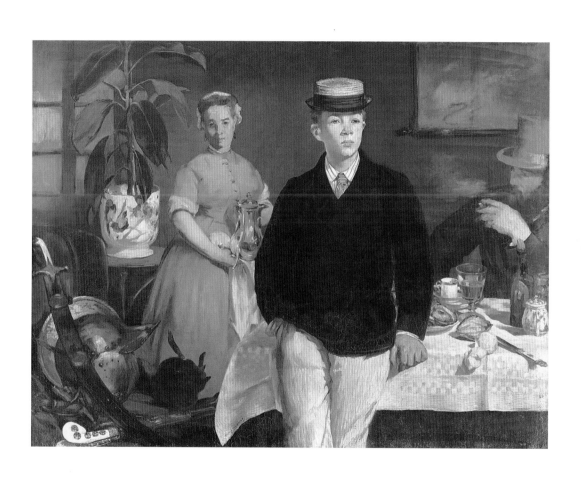

The Balcony

1868-1869
Oil on canvas, 169 × 125 cm
Paris, Musée d'Orsay

In 1867 Fantin-Latour introduced Manet to a young painter, Berthe Morisot, who immediately fascinated him. Later featured in many of his paintings, she posed for him here for the first time. The other two figures were also artists connected to Manet. Fanny Claus, a young violinist, was a friend of his wife Suzanne, and Antoine Guillemet, a painter who was well-situated at the Salon, helped Manet get his second medal in 1881 and let Cézanne exhibit at the official exhibition in 1882.

Again taking inspiration from a Goya painting, *Majas on a Balcony*, Manet arranged the figures behind the green iron railing on the terrace of his studio. The railing, whose color is repeated in the open shutters, takes up the entire lower half of the painting, and again scandalized critics at the Salon where the work was shown in 1869, leading Gautier to say that Manet "was competing with decorators." Though Manet had the women wear two lightweight white dresses and added other details to soften the sharpness of the green, as well as the blue of Guillemet's tie (such as the vase with the hydrangea, the floral bouquet in Fanny's hair, her ochre gloves, and Berthe's red fan) the cool, bright colors were judged overly harsh by his contemporaries, who also deplored, as usual, the lack of grace in his figures. As with *Luncheon in the Studio*, the figures do not speak to each other or look at one other. Each seems lost in their own thoughts, and Manet captures them in a suspended moment. Fanny is in the act of taking off a glove, and Guillemet has his hand hanging in the air. Berthe Morisot, intense and melancholy, wrote to her sister about her impression of the Salon, where she saw herself as "strange rather than ugly", and added, "It seems that those looking at me have murmured the words "femme fatale."

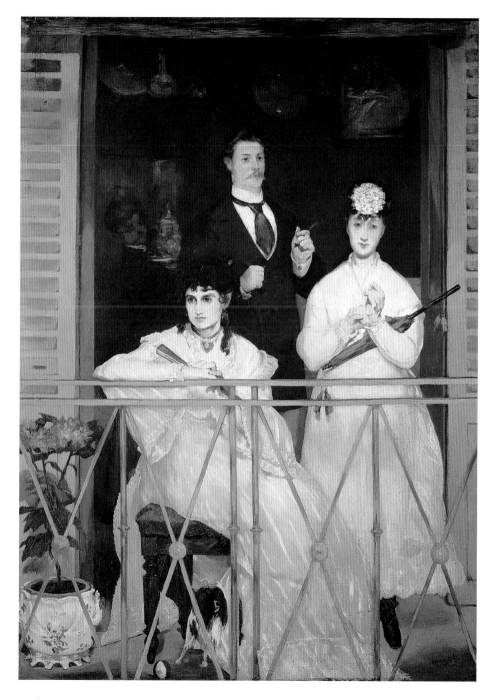

Repose (Portrait of Berthe Morisot)

1870

Oil on canvas, 148 × 113 cm
Providence, Museum of the
Rhode Island School of Design

After having portrayed her in *The Balcony*, Manet decided to make an individual portrait of his young friend, capturing her in a domestic, completely unconventional pose. The painting was made right after that of Eva Gonzales, the young Spanish woman who had ignited Manet's enthusiasm (and whom he took on as his only student), and had incited Morisot's jealousy. The relationship between Manet and Morisot, who was in her thirties at the time and not yet married, left much room for speculation and gossip in its wake, though their presumed romantic relationship has never been proven. Without question, Manet sincerely admired the work of the painter, an eminent impressionist who ended up marrying his younger brother, Eugène.

The title notwithstanding, Morisot remembered the agony of the long sessions of posing, during which she could not move her left leg, which was bent under her so as not to change the distribution of the skirt's folds. This strain is not evident in the painting, to which Manet gave an intentionally unfinished look, leaving the white armchair on the left and the Japanese print in the background in a sketched state. The figure of Berthe, wrapped in the white cloud of her dress, has an unfocused quality that makes her seem far from the present, absorbed in her thoughts, prey to those "chimera that made me unhappy" (as she wrote in a letter to her brother). The work, exhibited at the Salon of 1873, was criticized for these very reasons, all summed up by the critic Francion: "neither painted, nor drawn, nor standing, nor sitting." The delicacy of the presentation, the intimate atmosphere, and the execution, which show connections to impressionist works, made the piece a "modern" portrait, outside the bounds of academic precepts.

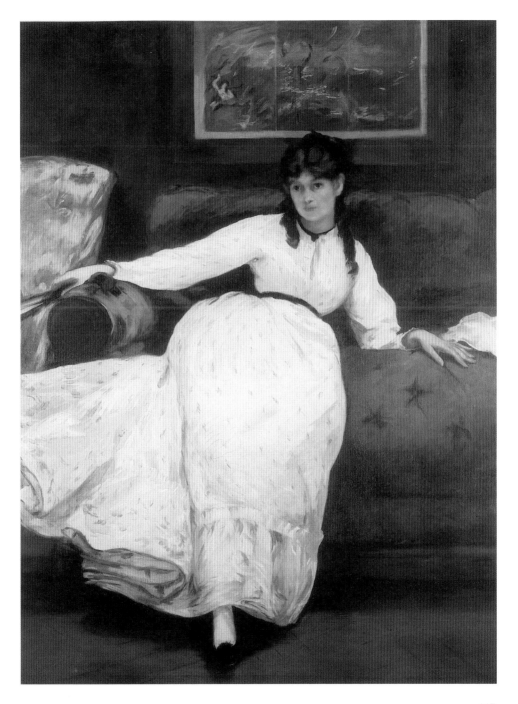

Berthe Morisot with a Fan

1872
Oil on canvas, 60 × 45 cm
Paris, Musée d'Orsay

The 1870s was the period in which Morisot and Manet were closest, up until her marriage to his brother. In this era, Berthe was the preferred subject of a vast series of portraits in oil and watercolor. This small work, which hangs in the Musée d'Orsay, did not have the official aspirations of *Repose*, a painting made for the Salon, and its domestic intent makes it a work of exceptional spontaneity. Manet wittily and affectionately portrays a private moment, in which Morisot, elegantly garbed in a black dress and a pair of light colored shoes, plays with him, bringing an open fan before her face, preventing him from making a real portrait. The young woman's lively eyes can be seen through the lower part of the fan, which seems to crown them, held with an elegant gesture of her hand. This creates a strong complicity between Manet and his friend, and he captures its fundamental details, letting secondary elements fall away.

Even in its speed, the composition is deftly structured. The figure of Morisot, wrapped in black material, stands out from the single color of the background wall, whose red seems artificially illuminated with a nighttime look that affects Morisot's skin, whose unnaturally warm luminosity is echoed in the visible part of her legs, her shoes, and the seatback. Berthe is sitting diagonally so that our gaze runs from her feet, which attract the eyes with their light color, along her whole figure, stopping to rest on her face. With his intuition and experience, Manet successfully amplified the effect by leaving the space to her right empty.

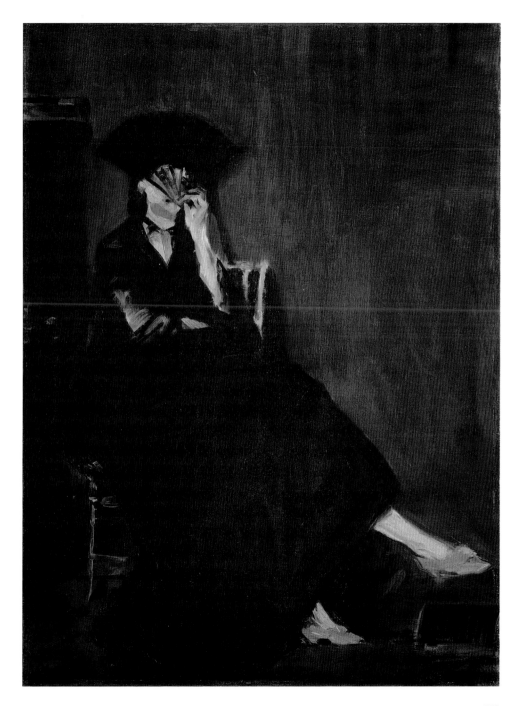

The Railway

1872-1873

Oil on canvas, 93 × 114 cm
Washington, National Gallery
of Art

In the late nineteenth century steam trains were considered the triumph of the industrial revolution, perceived as a great achievement at the times. They were often represented by the impressionists, running across bridges in the middle of the countryside or moving in the Gare Saint-Lazare. They were celebrated by Monet in a series of works in 1876 and 1877. Five years before him, in this painting, Manet had been the first to use the station as the focus of a painting, which was accepted at the Salon of 1874. He depicted his former favorite model, Victorine Meurent, posing ten years after *Olympia*, and the daughter of a friend, wearing an elegant white and blue dress. The woman is holding a book and a sleeping dog on her lap, a copy of the one in Titian's *Venus of Urbino*, which had been the source for his scandalous nude ten years before.

Returning again to the powerful theme of *The Balcony*, Manet portrays an iron fence whose bars mark the rhythm of the painting's entire surface. Here the bars separate the background from the painting's two female figures, keeping us, the ideal viewers on the same side, outside of the bars.

This extraordinarily innovative invention was predictably condemned by traditional critics with sarcastic remarks like, "These poor girls, seeing themselves painted like this, wanted to escape! But, with foresight, he put a grate to cut off any escape route." His friend and astute critic, Burty, understood the subtlety that informs the work, nothing that "The movement, the sun, the clear sky, and reflections all give the impression of nature, but a nature captured by a delicate spirit and translated by a refined soul."

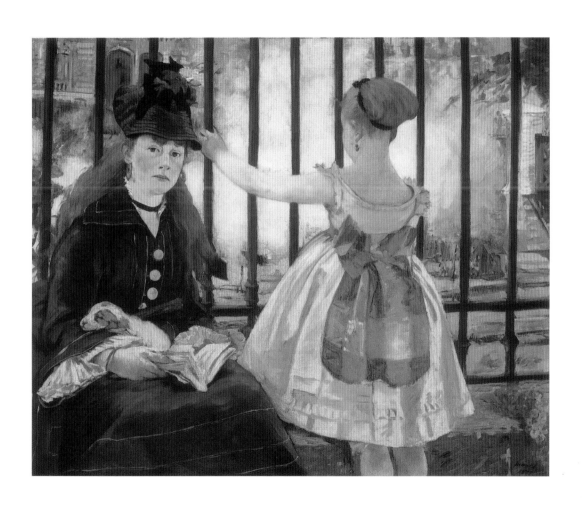

On the Beach

1873
Oil on canvas, 59.6 × 73.2 cm
Paris, Musée d'Orsay

During the summer of 1873, vacationing with his family on the Atlantic coast, Manet painted several *plein air* scenes. He had already worked outdoors, though mainly making sketches, which he later used to work in his studio. It was undoubtedly the influence of Claude Monet, a prominent member of the Batignolles group headed by Manet, and particularly close to him in the 1870s, which led him to paint completely outdoors, as evidenced by the grains of sand found on the canvas surface.

Scenes portraying figures on the beach had been a particular specialty of his chosen master, Eugène Boudin, and Monet had also painted several of them. Their works, however, used long perspectives, capturing groups of people who were usually moving, giving an impression of wind and leisure. On the contrary, Manet's painting is one of great concentration. The two subjects, his wife Suzanne, intent on reading, and his brother Eugène, in the same reclined position that he had adopted ten years earlier in *Le déjeuner sur l'herbe*, are still and engrossed. Most importantly, they are captured in a close foreground, with a tight perspective that crops the blue of the sky, leaving only a thin strip visible.

His choice of a very low horizon, and to portray the two figures in profile, making them appear as flat triangular shapes, similar to the dark sails of the boats that mark the visual rhythm of the background's blue, tie Manet's painting to Japanese prints. He had studied such prints for years, and they were elected a revolutionary model for the style of two generations of French painters.

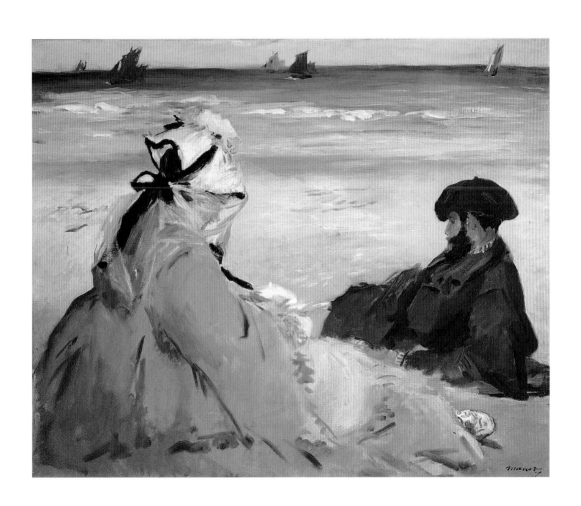

Le Bon Bock

1873
Oil on canvas, 94 × 82 cm
Philadelphia, Museum of Art

The painting, whose title means "the good mug of beer," depicts the etcher Bellot sitting at a table at Café Guerbois, the Batignolles group's gathering place since the mid 1860s. Shown at the Salon of 1873, the work replicated the 1861 success of *The Guitarist*. Critics and public admired the subject handled by Manet with unusual warmth. The figure was immediately likeable, with his rosy face, abundant stomach held by his partly-buttoned vest, and the details of his outfit, such as the knotted scarf around his neck and the smoke floating from his pipe. The more classic style and finished execution, less "patchy" than usual, made Manet's work acceptable, and even admired. For the exact same reasons, though from the opposite perspective, Manet's young colleagues did not appreciate the painting. They considered it a sinking of his standards, an obvious compromise with the inclinations of the jury and the academic public. His success even became a deterrent to continuing to represent at the official exhibition, as it made it clear that the only way to get the sought-after approval was to bend to traditional taste.

On the other hand, the work showed strong connections to the paintings of the Dutch Frans Hals, a contemporary of Rembrandt, whom Manet particularly admired and whose active, vibrant style undoubtedly influenced *Le Bon Bock*.

The baritone singer Faure bought the painting for 6,000 francs that same year. A few months earlier, a periodical had mistakenly announced that a collector was offering Manet 120,000 francs for his painting, which brought Manet into the editorial office, demanding that the journalist "name the madman who wanted to pay 120,000 francs" for his painting.

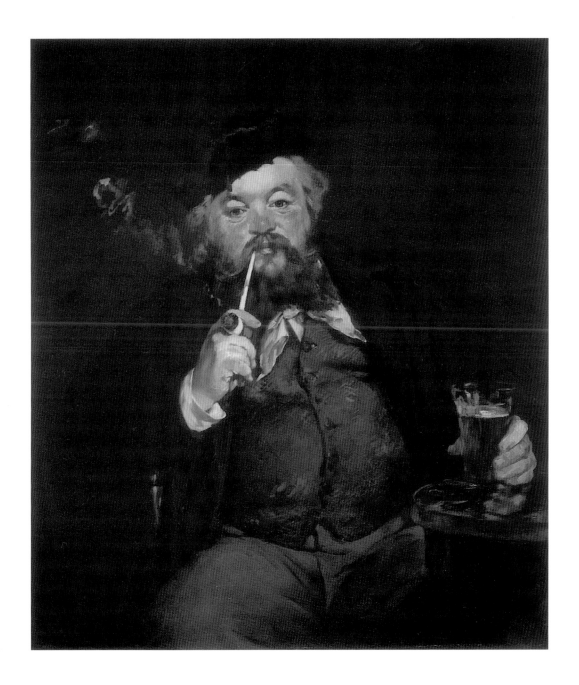

Woman with Fans

1873-1874
Oil on canvas, 113 × 166 cm
Paris, Musée d'Orsay

The painting depicts Nina de Callias, an eminent *bohémienne* of the era, who held a renowned literary and artistic salon frequented by poets, musicians, and painters such as Paul Verlaine, Stéphane Mallarmé, and Anatole France, as well as Manet. Esteemed composer and generous hostess, supporter and lover of many penniless young talents, she was also neurotic and alcoholic, already dying at only thirty-nine years of age.

Manet portrayed her in a kind of open box, like a black jewel standing out against the light background of the divan and the wall of the artist's studio, specially decorated for the portrait. The wallpaper and Japanese fans that adorn the background had been in fashion in Paris for some ten years. Renoir and Monet also used similar sets in their works from the same period. Nina wears one of the Algerian dresses that she liked to wear during her receptions, and her elegant garb contrasts with the casual pose in which the artist portrays her, reclined with an elbow propped on some cushions. Manet looks upon his model with clear fondness, grasping her psychology as well as her worldly aspect. The woman has a gaze both absorbed and tired, with a hint of a smile that does not mask her melancholy. In her image Manet captures the double nature of an urbane person and sensitive artist. Stylistically, Manet uses a rapid, lively touch that skims over details to convey the impression of the whole. The smaller, more fragmented brushstrokes that are found in some areas of the painting were unquestionably influenced by the ideas of his young colleagues, while the luminous, shiny black so characteristic of Manet triumphs in Nina's dress.

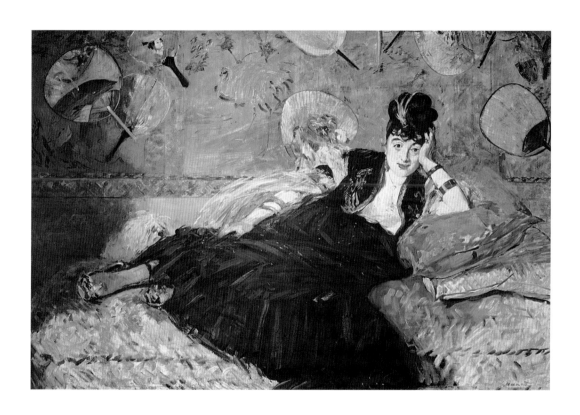

Argenteuil

1874
Oil on canvas, 149 × 115 cm
Tournai, Musée des Beaux-Arts

Argenteuil was a vacation area not far from Paris, a country town near the banks of the Seine. Claude Monet had established himself there, and his friend Renoir also visited often. Manet owned a family home near Gennevilliers, and spent the summer of 1874 there, the period in which he came closest to impressionist ideas. He had already made a few forays in that direction in previous years, and now assiduously dedicated himself to studying figures outdoors, and he may have completed entire paintings there, such as this one. Not only are the two figures portrayed directly on the river in the midst of nature, but, significantly, the painting is informed by a strong new luminosity and a fresh, genuine air is felt for the first time. A boatman (for whom Manet's Dutch brother-in-law posed) and a young woman sit on the edge of a boat. The man shows clear interest in his companion, while she gazes expressionlessly in front of her. According to Théodore Duret, Manet had perfectly captured the spirit of these Sunday couples, whose middle-class women had insipid, lazy ways. However, the painting's exceptional quality is in its rapid and lively execution. Manet delicately modulates the colors, giving up strong dark and light contrasts almost entirely in favor of a continuous mixture of light and shadow. His clean and essential marks achieve unprecedented tension in the woman's skirt and flowers, where the colors merge and affect each other like in the works of the impressionists.

The work was exhibited at the Salon of 1875, where it was, of course, poorly received by traditional critics, who declared Manet's "bankruptcy" after his isolated success with *Le Bon Bock*.

In the Boat

1874

Oil on canvas, 97.2 × 130.2 cm
New York, The Metropolitan
Museum of Art

This work was painted during the summer of 1874, when Manet met often with Monet and Renoir. In its unusual, very close-up perspective, now with no horizon at all, the painting is reminiscent of *On the Beach*, painted a few years earlier. However, here, the luminosity is much more pronounced, and the sunny day is seen in the reflections on the face and white shirt of the boatman for whom Suzanne's brother once again posed. The identity of the woman, who wears the same hat that the Manet's wife wore in the other painting, is unknown. As in *On the Beach*, here Manet takes inspiration from the bold compositions of Japanese prints, where figures and objects are often cut off by the limits of the surface.

The work, constructed with a sure hand, revolves around the vivid contrast between the blue stretch of the water, the brown of the boat, and the two figures. Though he had always been an expert at refined tone-on-tone effects, the variations of the white and purple take on a new character here, infused by light. Though Manet was certainly influenced by the works of his young friends, he developed them in an entirely personal way. The subject has no connection to Monet or Renoir's works, and the painting also appears considerably more structured than theirs. Though Manet displayed a great deal of autonomy, the critics who saw the painting at the Salon of 1879 launched the same accusation against him as against the impressionists, namely, that he used his eyes, rather than his head, in his work. Only the young Huysmans appreciated the painting's quality, supporting the painter's right to represent what he sees how he sees it, the very lesson that Manet had imparted to Eva Gonzales ten years earlier.

131

Monet Painting in His Floating Studio

1874
Oil on canvas, 81 × 100 cm
Munich, Neue Pinakothek

Manet's close relationship with Monet reached its peak in the summer of 1874, and is unequivocally stated in this unfinished painting, as well as another similar one. Manet imposed long sitting sessions on his models. He likely did not wish to subject his friend and his young wife to such a procedure, complicated by the subject itself. The idea of a floating studio was not Monet's. He had taken it from Daubigny, an eminent Barbizon landscape painter and friend and supporter of Monet's, who experimented with the idea, which became well-known for its originality in the 1860s.

The painting's true focus is the boat itself, which covers almost the entire length of the surface. Monet is portrayed in profile, intent on working on a painting still in a draft state. His wife Camille is cloaked in a white dress, contrasting with a black hat, and watches him paint at a respectful distance. The shore of the Seine can be seen beyond the boat, where the green of the countryside merges in the distance with the factories of the Parisian outskirts. The light-colored, luminous painting (despite the black swath of the hull) is dominated by the blue tones of the sky, the boat's cabin and, especially, the water. The rendering of the water is what brings Manet's painting closest to those of his colleague. Manet uses a dynamic, vibrant hand, boldly stippling the water with yellow, green, pink, and black with the same process of colored shadows and mutual reflections that Monet was busily applying to his works in this period.

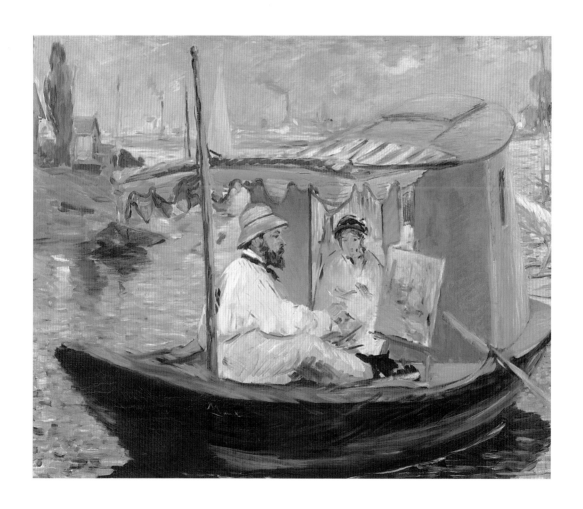

Madame Manet on a Blue Sofa

1874
Pastel on paper mounted
on canvas, 50.5 × 61 cm
Paris, Musée du Louvre,
Cabinet des Dessins

This is probably the first pastel made by Manet, who would later primarily use this technique for an extensive series of female portraits between 1879 and his death. Much in vogue throughout Europe in the nineteenth century, pastel had been gradually abandoned, and the artists of the Batignolles group rediscovered it. It is unclear who deserves credit for getting there first, but the contest is certainly between Manet and Degas, who experimented at length with its expressive potentials in the *Dancers* and *Woman at Her Toilette* series.

This work depicts Suzanne reclined on a couch, captured in a moment of rest before or after a walk, as indicated by her jacket, elegant shoes, and her hat with the undone tie. The subject was often taken on by Renoir and Monet, who painted Monet's wife, Camille, stretched on a divan several times in the same period. There is no need to theorize direct influences, as the painters' discussions would have naturally led them to work on the same subjects.

Manet took advantage of the velvety effect of pastel, which oil paint lacks, though he again made an image firmly anchored in painting tenets, as seen in the large contrasting color surfaces, as well as the effect of the sofa's slightly mussed fringe.

The work was bought by Degas, who kept it in his studio for the rest of his life. When his collection was sold, the Louvre bought it for 62,000 francs.

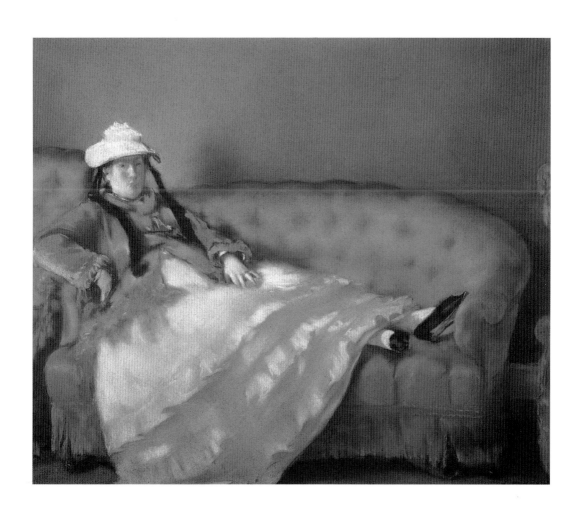

135

Portrait of Marcellin Desboutin

1875
Oil on canvas, 192 × 128 cm
São Paulo, Museu de Arte

Desboutin was a painter and etcher from an aristocratic family who had studied at the École des Beaux-Arts, though he subsequently married the impressionist cause, and, therefore, poverty. It is unknown where the two artists met, though most likely it was at Café Guerbois, which Desboutin started to frequent around 1870, or at the Café de la Nouvelle Athènes, the new headquarters of the Batignolles group since 1872. Manet considered the etcher "the most extraordinary fellow in the neighborhood" for his composure and serious dignity; he was also Degas's model for *The Absinthe Drinker.* Manet portrayed him standing with a neutral background like he had used in many previous portraits. He abandons the ranges of gray in favor of brown tones and a warm luminosity. The dog, though with distant echoes of those depicted by Velázquez and Jacopo Bassano, is painted in a new style, with a dynamic touch and a chiaroscuro effect that fills the animal's figure as he is intent on drinking from a glass. Manet intended to place himself as an heir to the great painters of the past, equaling their creations in modern interpretations. For Desboutin's portrait he used a freer execution and more exuberant brush strokes than before, which did not win the favor of the jury of the Salon of 1876, who rejected his painting with thirteen negative votes out of fifteen total. The academic world was dismayed by the success of *Le Bon Bock,* and especially by the semblance of legitimacy thereby created for a painter who was at the same time identified as the leader of impressionism. Discouraged and furious, Manet organized an individual counter-exhibition in his own studio, visited by a large crowd. The invitations came with the slogan, "Make it true and let others talk." The realist critic Castagnary took him up on that, and declared that he now held a place in contemporary art on par with those of the most eminent artists on the jury.

137

Portrait of Stéphane Mallarmé

1876
Oil on canvas, 27 × 36 cm
Paris, Musée d'Orsay

Manet's personal and artistic connections with the progressive writers of his age was a defining feature of his life. First he was friends with Baudelaire and Zola; in 1873 he met the young poet Stéphane Mallarmé, who, as the others had, quickly picked up his pen to defend and praise Manet, whom he considered "the only man who has tried to open a new path in painting", as he wrote in the article "The Painting Jury of 1874 and Manet," published less than a year after they met. An intense personal and professional understanding was born between the two at the instigation of Mallarmé, ten years Manet's junior. Manet made illustrations for several of the poet's works and translations.

The extraordinary natural quality of Manet's portrait of him makes it one of the highest and most modern achievements of his career. The small painting has extraordinary expressive power and charisma. The writer is captured in a quotidian moment in Manet's studio near Gare Saint-Lazare, which can be recognized by the wallpaper also found in *Woman with Fans*. Far from the official quality (even pomposity) of the Astruc portrait, Mallarmé is depicted with a hand in his pocket and his back resting on a cushion arranged against the wall. His other hand holds his beloved cigar and seems to indicate a point on a page, as if he were marking his place during a conversation or a pause for thought.

Here Manet gives up on his notorious, strenuous posing sessions, allowing him to achieve an effect of great immediacy. The economy of the rapid brushstrokes and the engrossed poet's crooked position convey a communicative intensity uncommon in the generally cool atmosphere that Manet favored.

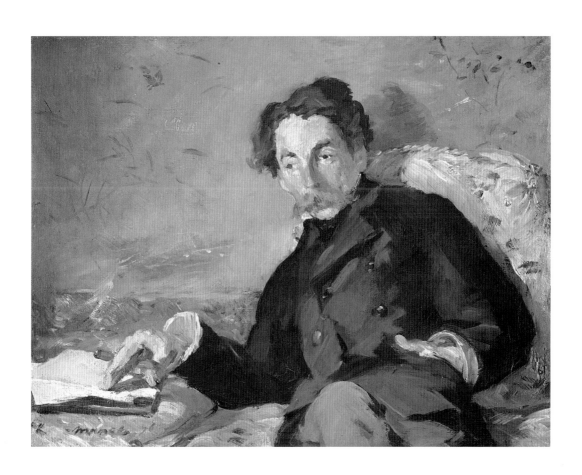

Nanà

1877
Oil on canvas, 150 × 116 cm
Hamburg, Kunsthalle

The character of Nanà appears in the last chapters of Émile Zola's novel *L'assommoir*, published in 1876; she is an intelligent young social climber who chooses to become a high-class prostitute to make her way to the top. The author portrays a vain girl: "Early in the morning she began her preparations and stood for hours in her chemise before the bit of broken mirror nailed by the window." Manet chose to represent this specific feature of her character, lightweight and even amusing, like an enormous powder puff, doing away with any hint of biting social criticism. Nanà pauses for a second while putting the final touches on her make-up to turn unhurriedly towards the viewer. The painting's tones are based on whites and blues and its atmosphere is cheerful. The inclusion of the figure in the top hat casts an air of obtuseness on him rather than on the girl. The man is stiff and impatient, in contrast to Nanà's dreamy distraction, and prefigures the Count Muffat in the novel *Nanà*, which Zola dedicated to the prostitute in 1880. The Count's figure is cut in half by the painting's edge. The work was rejected from the Salon of 1877, predictably, as it was an open provocation given the subject matter, its style so close to impressionism, and its excessive size. Manet exhibited the painting nonetheless at the dealer Giroux's gallery, raising the usual "indignant cries or laughs," as told by Huysmans, who dedicated an article exclusively to the painting. The subject was much discussed in the naturalist realm, in literature as well as in painting. Manet showed once again his firm desire to "be of his own time." However, he chose a playful tone that went back to the ironic and gallant tradition of the eighteenth century, rather than the theme of the *femme fatale* which he had shown fifteen years before with *Olympia*. The scandal was also fueled by the model being recognizable as a young actress who was also lover of the Prince of Orange at the time.

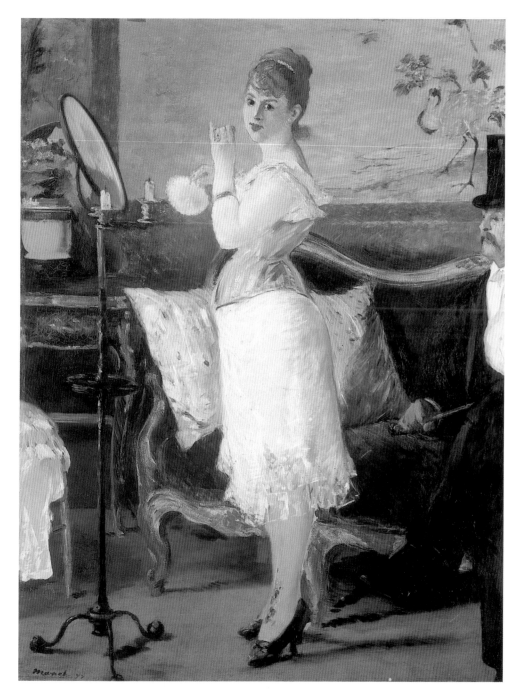

Skating

1877
Oil on canvas, 92.5 × 72 cm
Cambridge (Mass.), Fogg Art
Museum

Manet enthusiastically returned to representing scenes of Parisian society at leisure, going back to the idea of some of his early works, such as *Music in the Tuileries Gardens*. He chose to show a skating rink frequented by high society, celebrating one of the places of modern recreation that Baudelaire had extolled in his famous 1863 writing. The words of the great poet seem to form the back-drop of the painting. He asked artists to portray "the transitory, the fleeting, the contingent," and Manet recorded this very aspect of modernity. Staying true to the dictates of his dead friend, which were the same as his (both were absolute "men of the world"), Manet made "a sketch of customs, a representation of bourgeois life and fashionable shows."

The woman in the foreground is Henriette Hauser, a young actress quite well-known in the milieu of the boulevards for being the lover of the Prince of Orange. Manet had met her in Nina de Callias's house, and she had already posed *deshabillé* for *Nanà*. The woman has a dis-tracted, smiling expression, though without the coquettish air she had in *Nanà*, also inspired by Zola's novel. She wears an elegant em-broidered jacket, what appears to be a lightweight skirt, and the ever-present pair of gloves, a constant attribute of refined figures. Manet paid special attention to reproducing her elaborate outfit, which becomes the focus at least as much as Henriette herself. With a masterful hand—dynamic and lively—Manet perfectly conveys the lightweight atmosphere of the evening, filling the surface with an amorphous, noisy crowd and creating a moving, animated image, very different than the static quality of *Music in the Tuileries Gardens* from 1862. Though his brushstrokes show the undeniable influence of his impressionist friends, he stays true to himself, orchestrating a proper "symphony in black".

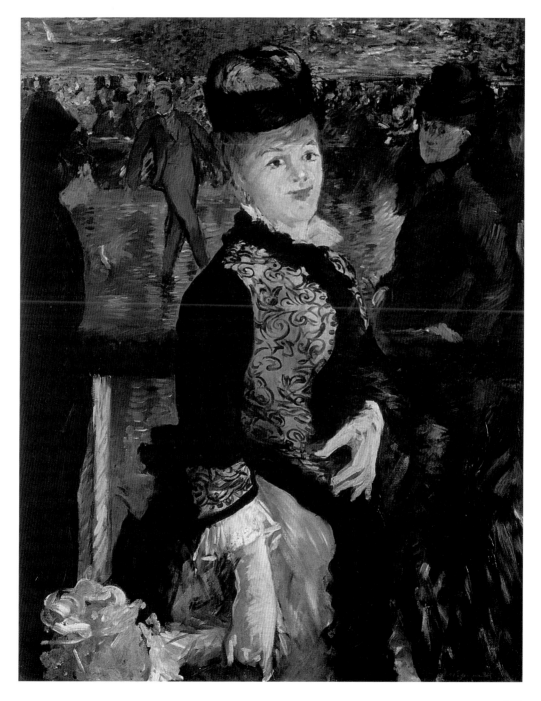

The Plum

1877-1878
Oil on canvas, 73.6 × 50.2 cm
Washington, National Gallery
of Art

The world of Parisian cafés was a mainstay of late nineteenth-century life, literature, and painting. They were meeting places for groups of thinkers and artists, and forums for discussing ideas and launching theories. They also became backdrops for many works of art, and were particularly favored by the two "city dwellers" of the Batignolles group, Degas and Manet. Manet had even bought a little table with a marble top to keep in his studio in order to artificially recreate the atmosphere of the cafés.

This work, currently in Washington, shows an impressive modernity and evinces marked points in common with a famous Degas painting from 1876, *The Absinthe Drinker*, in which a woman, ruined by alcohol, sits desolately at a little table on which a glass of liquor is set. Similarly, as if to distantly mirror his fellow painter's work, Manet chose a title that makes the content of the cup the focus of the scene rather than the woman. He also chose an uncommon, photographic angle, capturing the figure from an even closer perspective than Degas did. Finally, he paints the tabletop with a similar effect, almost as if it were an object hanging in the air, though using a different painterly device than Degas. He includes the table's iron leg, yet, unlike Degas's angular view, he chooses a frontal view, letting the edge of the surface cut the table.

In the past, the woman was often interpreted as a prostitute, though a more recent theory casts her as a variation on the theme of a daydreaming woman lost in her thoughts, commonly depicted by painters of the era. Regardless of the meaning of the scene, Manet creates an image that is new and full of melancholy, suggested by the clear colors in the foreground that make the girl a kind of pink cloud against the bright background that brings her back to reality, though in a poetic version quite free from Degas's bitterness.

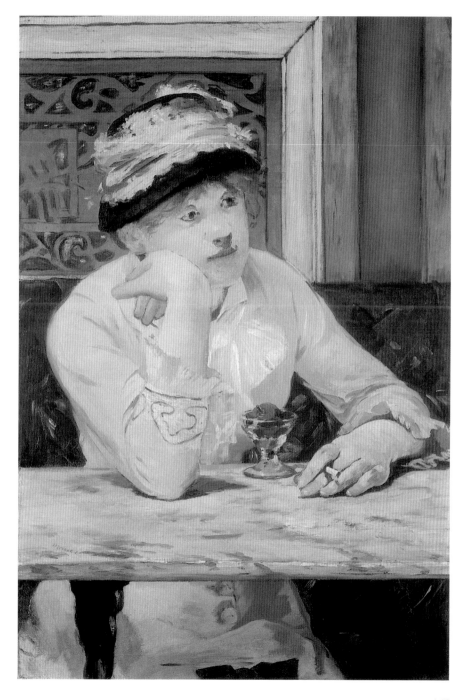

Blonde with Bare Breasts

1878 (?)
Oil on canvas, 62 × 51.5 cm
Paris, Musée d'Orsay

Manet drew from two different sources for this work: secular sixteenth-century Venetian painting (the works of Tintoretto and Titian in particular) and the paintings of his young impressionist friend Auguste Renoir, who was the contemporary specialist in the nude female half bust. Manet's work seems, in fact, to be a kind of challenge to his colleague, as critics, commenting derisively on the purple and blue reflections in the skin of one of his figures, suggested that the artist had found his models at the bottom of a canal. Manet did not go so far as to paint the reflections of the surrounding environment on the woman's skin. Instead, he shapes it by turning his brush with a sure and rapid hand, marking the form's edges with a dark line. Contrasting with the finished, polished look of the woman's body, the dress has an irregular look, the hairstyle is tousled, and the yellow hat, quickly sketched, adorned with a few red flowers. The background is disorderly and covered with a bright green color which serves as a visual buffer, bringing the female figure, and her serious, thoughtful face, towards the viewer.

Manet's wife, Suzanne, sold the painting to the dealer Ambroise Vollard (a pioneer supporter of modern painting) in 1894 for 500 francs, a price that seems quite low for the time. It was later bought by Moreau-Nélaton, a leading Manet collector and scholar, who donated it to the Louvre in 1927.

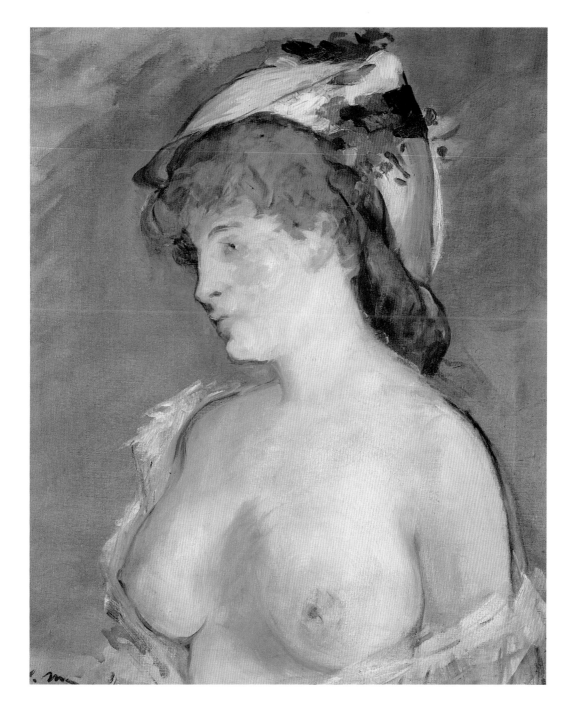

The Tavern – La Guinguette

1878
Oil on canvas, 73 × 91 cm
Moscow, Pushkin Museum

The title brings to mind an impressionist work, immediately evoking Renoir's paintings, but *La Guinguette* also draws on Japanese art. Choosing an unusual perspective, much like a snapshot, and adopting a sequence of parallel planes, Manet paints a table, the backrest of an iron chair, a seated woman resting her elbows on the counter, and a corpulent man in profile. Adapting the revolutionary device of *The Railway*, Manet paints a bottle and a glass in the foreground that seem to be resting on the edge of the painting, giving the illusion that the person viewing the painting is actually in its space, sitting at one of the bar's tables. The invention was quite intriguing, soliciting an uncommonly active participation by the observer. The trunk of a tree strengthens the impression, running vertically along the surface on the scene's right, revealing another bottle and half a window behind it. The use of these kinds of shapes cut by the natural limits of the space of representation was typical of Japanese art, which Manet had long admired.

Using the vibrant brushstrokes typical of this period, Manet creates a highly original image, painting a luminous center (the back of the customer bent over the table) between two dark planes (the gray area near us and the background wall). The careful juxtaposition of forms imposes a lively rhythm, suggesting a diagonal reading. The bottle and glass in the foreground, combined with the curve of the seat's back, are taken back up and reversed in the second table, separated by the vertical line of the trunk. The curved volume of the central figure has a counterpoint in the hefty person in the background whose blue jacket is answered by the black details of his hat, tie, mustache, and hair.

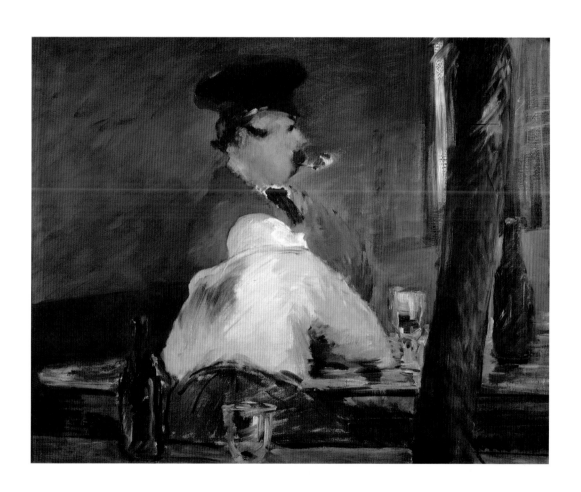

The Waitress

1879
Oil on canvas, 77.5 × 65 cm
Paris, Musée d'Orsay

The painting, which Manet called *Serveuse de bocks,* is a different version of one from the same year (London, National Gallery), here with a closer and weightier perspective. Manet employs a mode of composition that recurs in his paintings from this period, which takes the viewer's gaze into consideration. Manet again uses, to a much greater extent, the device of having the people and objects cut by the natural end of the canvas. Here, the method is used for all four sides of the painting. The figure of the person in the foreground, the beer mugs on the right, the lights on the upper edge, and the body of the dancer to the left are all only half depicted, so that the viewer has the impression of participating in the scene. The surface is also cut in two vertically. The left side has a reddish background, marked diagonally, in front of which the spectators' top hats rise; the right area shows a wall with a lightcolored wallpaper decorated with flower bunches, in front of which the waitress turns and looks at us. Stylistically speaking, the work expresses strong similarities with impressionism, though Manet sticks with his more contrasted palette and, significantly, chooses not to adopt a uniform kind of execution. For the left half of the painting, as for the foreground figure, he uses a broken, often diagonal brushstroke. The face of the man intent on smoking the pipe fully adheres to the studies of his younger colleagues. The figure's skin and hair are broken down into several hues, and Manet makes heavy use of colored shadows. The waitress's face and the collar of her dress are made with a more traditional technique, painted with patches of color.

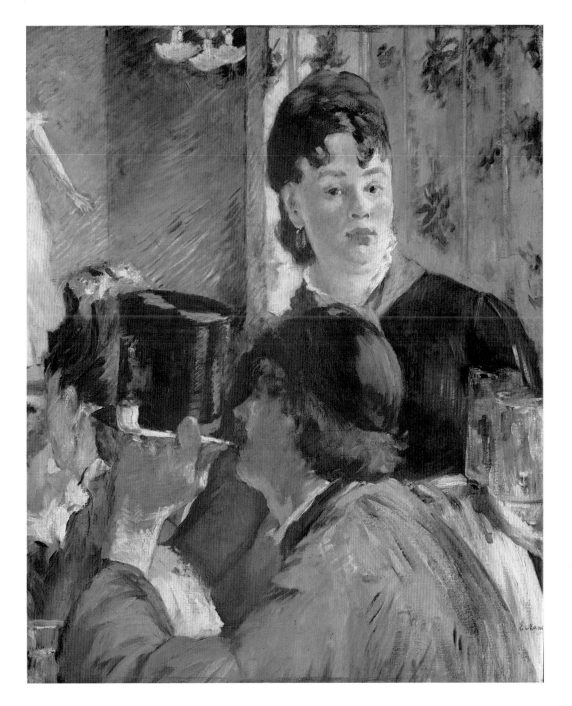

In the Conservatory

1879
Oil on canvas, 115 × 150 cm
Berlin, Nationalgalerie

This portrait of a couple portrays the Guillemets, owners of an important fashion boutique, unrelated to the painter of the same name who had posed in *The Balcony*. Manet took the idea of the railing from *The Balcony*, and doubled it, though with a weaker impact than in the painting from ten years earlier. The space is quite carefully constructed. The geometric weight of the bench is countered by the proliferation of plants in the background. These plants alternate with the figures and set a pace for the space's horizontal view. Their green mass, though handled like wallpaper, gives particularly vibrant emphasis to the yellow of the accessories worn by Madame Guillemet, renowned for her beauty and good taste. The couple's apparent distance is contradicted by the closeness of their hands, introducing an intimate atmosphere.

Conservatories were a fashionable setting during the Second Empire. Zola turned them into places of clandestine romantic encounters in his 1872 novel, *La Curée*, and succeeded in raising a scandal. Manet exhibited the painting at the Salon of 1879, where the association with Zola was advanced by some malevolent critics, despite its lack of ambiguity. The painting was exhibited together with *In the Boat*, setting an intentional contrast between the social status of the two couples. Manet had managed to obtain a meeting with the assistant secretary of state, suggesting the public purchase of one of the two paintings or the admired *Le Bon Bock*, in order to be represented in Luxembourg in the Museum of Contemporary Art. The offer was ignored and the state never bought any works by Manet during his life. Attesting to the work's vitality and its evoking of an era, however, in the recent film based on the Oscar Wilde novel *The Ideal Husband*, this painting is explicitly quoted in one of the final scenes.

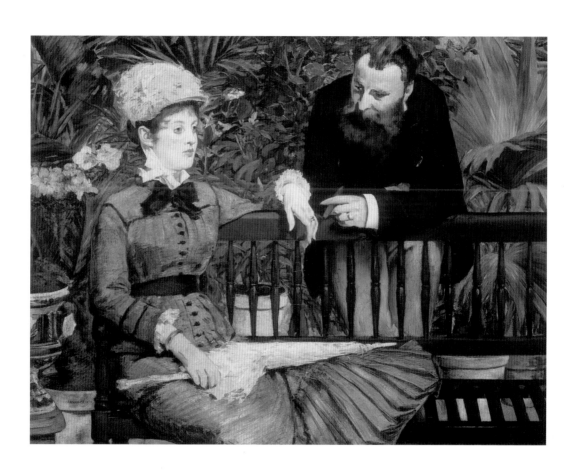

153

Self-Portrait

c. 1879
Oil on canvas, 83 × 67 cm
New York, Private collection

This is one of Manet's extremely rare self-portraits. His features are familiar from Fantin-Latour's painting (including a portrait of 1867, now at the Art Institute of Chicago) and the description written by Zola in his *Biographical and Critical Study*, also from 1867: "Édouard Manet is of medium stature, smaller rather than larger. His hair and beard are light brown; his eyes are narrow and deep, and have a youthful liveliness and fire … . His face has a fine and intelligent irregularity, which as a whole professes agility and daring, disdain for stupidity and banality. If we move from the face to the man, we find in Édouard Manet a person who is exquisitely amiable and courteous, with distinguished ways and a likeable appearance."

At the time of this self-portrait Manet was forty-seven years old, but his features still convey the characteristics evoked in his friend's analysis. He portrays himself with a brush and palette in hand, though wearing his jacket and hat, which he is unlikely to have worn while painting. This is a constructed presentation, in which Manet depicts himself as a dandy, according to Baudelaire's precept, though the pose is also reminiscent of the mirrored pose in *Las Meninas* (Madrid, Prado) by Velázquez, Manet's favorite artist, of whom he aspired to be a modern equivalent. Manet drew on one of his oft-used color combinations to paint himself: a neutral background of a brown hue against which the ochre of the jacket stands out, taken back up in the brushes and palette, almost is if the artist wished to say that his realization as a man moved entirely through his work.

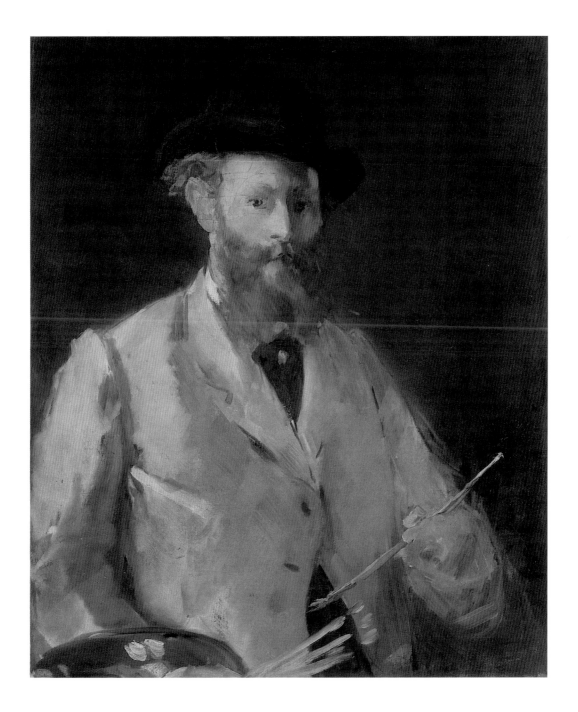

At Père Lathuille's

1879
Oil on canvas, 93 × 112 cm
Tournai, Musée des Beaux-Arts

The Père Lathuille was a restaurant in the Batignolles neighborhood, near Café Guerbois, where Manet gathered with his friends and colleagues. The painting, which has a fresh and spontaneous air, does not immortalize two strangers, but rather a couple constituted by posing the son of the café owner with the actress Ellen André, a friend of Manet's. André's acting commitments forced Manet to replace the model, and he also decided to change the young man's clothing, who was originally painted in a dragoon uniform. In contrast to the usual coldness of Manet's characters, he gives a close, amused description of the psychology of the improvised couple.

The woman is visibly older than her companion, and has a composed and rather rigid posture, with her back held away from the seat, her mouth tight and her gaze lowered. The young man, who seems to have grown his mustache and sideburns to look older than his age, is relaxed and outgoing. Bending towards his companion, with this eyes fixed on her face, he familiarly stretches an arm on the backrest of her chair, while his other hand distractedly grips a glass whose contents echoe the yellow of his jacket. Manet also chose the colors to emphasize the distance between the reserved reticence of the woman dressed in dark clothes and the warm, expansive attitude of the young man, with bright clothing, tempered by the black scarf knotted around his neck. Manet's spirited brushstrokes portray a wide view of the cheerful restaurant with its decked out tables in an internal garden. On the right, behind the young man's hand, he painted a waiter who stops to watch the scene of courtship, perhaps ironically mirroring our voyeuristic attention as spectators magnetically drawn to the couple.

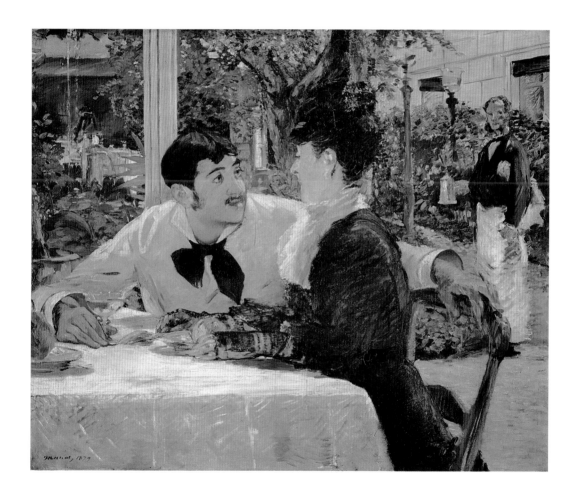

The Asparagus

1880
Oil on canvas, 16 × 21 cm
Paris, Musée d'Orsay

This small painting has an interesting story behind it. Manet had painted an asparagus bunch (now in Cologne, Wallraf-Richartz-Museum) against a black background on a bed of leaves in the manner of seventeenth-century Dutch still lifes. The piece had been bought for 800 francs by his friend, an art historian and banker, Charles Ephrussi, who had instead sent 1,000 francs to Manet. Manet, who was equally the gentleman, chose to thank him as best he knew how, by giving him another painting. He made the painting and sent it to Ephrussi with a note: "One was missing from your bunch."

Unlike the first work, which was conventional and structured, *The Asparagus* presents an extraordinary expressive and compositional freedom. The tiny piece of produce is placed on a marble top that runs slightly diagonally to the painting surface. The table runs vertically up the entire available space, free of any other indication of place or time. The color combination also evinces great sophistication. Manet chooses an elegant tone-on-tone variation, echoing the asparagus's ivory hue in the table material, and repeating purple, pink, and green tones in the veins of the asparagus's tip.

Though the painting originated in a particular circumstances, it is related to a small group of similar pieces from the same period, often made as small gifts, such as the aforementioned bouquet of violets for Berthe Morisot, and three apples painted for another friend, Méry Laurent. Similar themes, mostly in watercolor, are also found in Manet's letters accompanying his writing.

The Viennese (Portrait of Irma Brunner)

1881

Pastel on paper, 54 × 46 cm
Paris, Musée d'Orsay

Starting in the late 1870s, partly due to his declining health, Manet increasingly worked on portraits of women in pastel. His models were mainly friends who were enchanted with how he captured their image and exalted their refinement. He expressly asked them to wear their most elegant outfits, often crowned by large hats.

The portrait of the Viennese Irma Brunner, introduced to him by their common acquaintance Méry Laurent, is among the finest of these. The young woman is painted in profile, which emphasizes the regularity of her features, evoking the grand ladies of the Italian Renaissance. Taking full advantage of the naturally velvety and soft effect of pastel, Manet works with the contrasts in tone that mutually enhance one another. The black mass of her hair and hat make her white face all the more luminous, clearly made lighter than natural by make-up, as seen by the more intense pink of her ear. Balancing the black, which is brilliant yet impressively delicate, as only Manet could make it, there is the pink swath of her high-necked dress, which shapes the contour of her body. A neutral background of a luminous gray tone completes the color harmony, enlivened by her bright red lips.

Edgar Degas also made abundant use of pastel, experimenting with all of its potential. However, his portraits explore the psychology of its characters in depth; Manet, in contrast, tends to paint his models as if they were beautiful flowers.

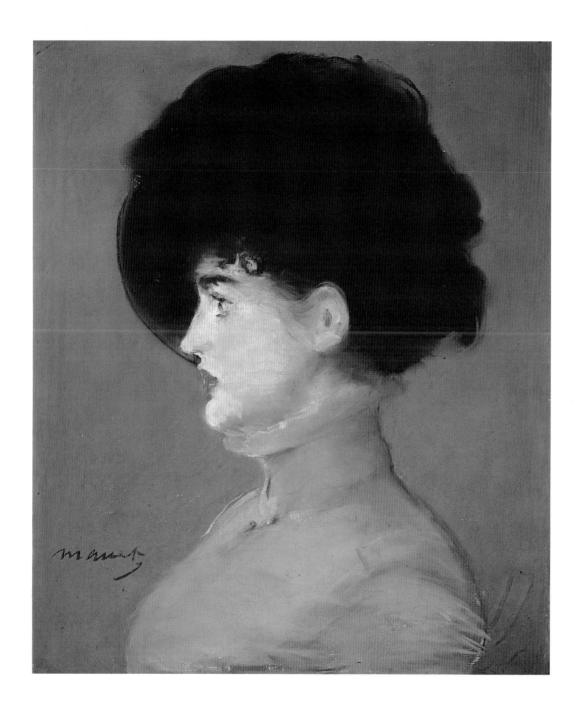

The Escape of Henri Rochefort

1881

Oil on canvas, 146 × 116 cm

Zurich, Kunsthaus

Henri Rochefort was a liberal intellectual who became famous during the Second Empire for his scathing pamphlets directed primarily against the emperor, Napoleon III. After the fall of the Commune he was imprisoned and deported to New Caledonia in 1873, from where he made a daring escape the following year. He returned to Paris in 1880, with amnesty, turning, however, into an ardent anti-Semite. Manet, who admired the radical Republican in him, undoubtedly met him in 1880, at the latest, through their friend Desboutin.

The pamphleteer, who was now surrounded by an aura of legend (in a letter to Manet, Desboutin dubs him "Robinson-Rochefort," a clear allusion to Robinson Crusoe), had escaped with four companions with whom he managed to board a whaler and reach the American coast. Manet romanticized the event to charge it with extra drama and heroism. The escape was not actually in the open sea, but in a commercial port off the island where they were kept prisoners. It was also not Rochefort who took the helm, as Manet represents him, turned quietly towards the viewer.

Manet intended to present it to the Salon, returning to the idea of a historic sea scene, as he had done with *The Battle between the Kearsarge and the Alabama*, though now radicalizing the composition. The small wooden boat in the painting's center, completely surrounded by choppy water, takes up almost the entire stretch of the painting, interrupted only by the line of the high horizon, which shows a night sky in the background and two ships in the distance. Manet later changed his mind and presented another portrait of Rochefort to the jury, likely to avoid criticism about the truthfullness of the event.

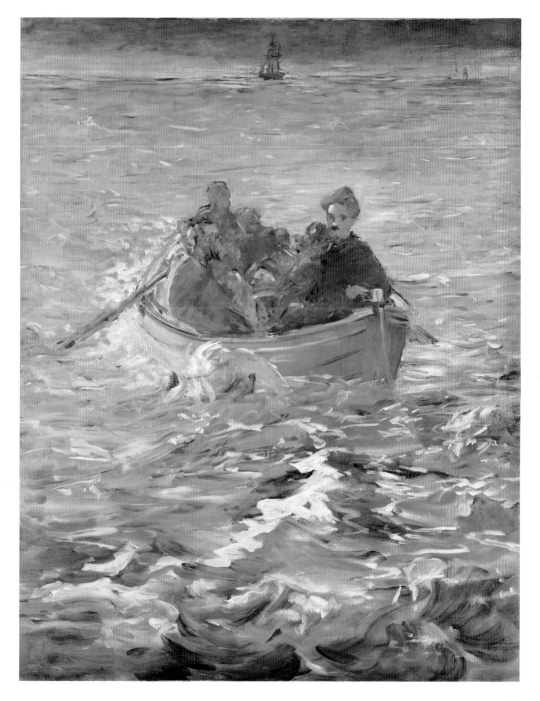

Autumn: Portrait of Méry Laurent

1881
Oil on canvas, 73 × 51 cm
Nancy, Musée des Beaux-Arts

Méry Laurent met Manet in 1876, visiting the individual show put on in his studio after yet another rejection from the Salon. She was a sophisticated and charming woman, close to many members of the art world, a great love of Mallarmé, as well as a model for Odette Swann in Marcel Proust's *Remembrance of things Past*. She was the subject of many paintings and pastels in Manet's later work, and she became his closest friend, staying by his side throughout his illness.

The painting's title comes from a request from his friend Antonin Proust (unrelated to Marcel), who had ordered four female portraits from Manet as allegories for the seasons, though the series was never completed. Méry Laurent had posed for autumn because of the fur she wore. She had recently bought it at a top boutique and it had enchanted Manet, who always loved the elegance of women's clothes, to the point that he made his friend promise to give him the piece as a gift once it was worn out.

Méry is portrayed in a three-quarter profile, with a perspective from below, which renders her statuesque while exalting the admired fur. The dark color of the fur contrasts vividly with the brilliant and luminous blue of the background, decorated with tiny, brightly colored flowers. It is not completely clear whether this is wallpaper or a pond painted outdoors as the light pink shading suggests, reminiscent of the clouds reflected in the water in Claude Monet's waterlilies. Perhaps the choice of color has a specific reason; Méry was famed for the particular pink of her skin, also extolled in a poem by Mallarmé, to which Manet gives special attention, using the oil paint almost like pastel.

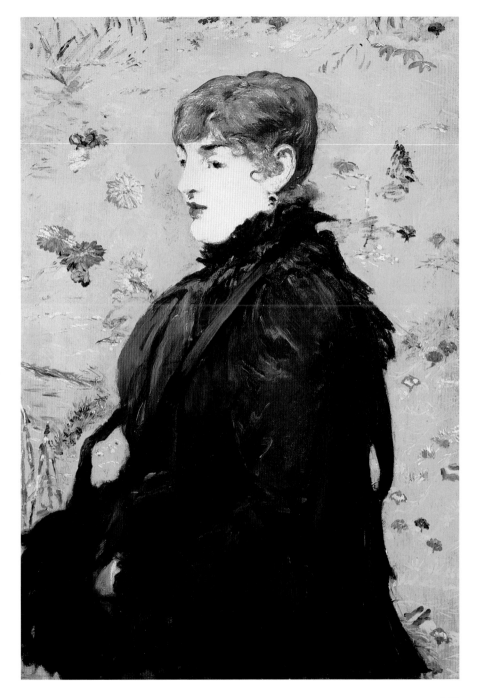

A Bar at the Folies-Bergère

1881-1882
Oil on canvas, 96 × 130 cm
London, Courtauld Institute
Galleries

This was the last major painting by Manet, long considered his final testament, evidencing both the development and absolute internal coherence of his artistic career. The painting contains many of the characteristic components of his entire career: the Parisian setting, the slice of modern life, its calibrated composition, and the use of black and extraordinary still life. However, the piece has a psychological subtlety rarely achieved by the artist, along with a very balanced execution, touched with impressionist echoes interpreted in a personal manner.

Manet once again plays with the effect of placing the viewer within the painted space, though here he weaves a particularly subtle dialogue between the observer and the observed. At first glance, it gives the impression of a conventional scene in which the barmaid, absorbed and melancholy, looks at us without seeing us, and behind whom we have a wide view of the customers at the crowded bar. A closer look reveals the detail to the right, making us aware that everything we see behind the girl is actually a mirror reflection. The spatial relationship is unexpectedly complicated and the customer in the top hat to whom the barmaid turns without seeing him coincides with the viewer.

As in the masterpiece by the much-venerated Velázquez, *Las Meninas*, reality is not as it appears. The attitude that seems solicitous, when looking at the girl from the back is not actually there. The Folies-Bergère, a concert café in vogue at the time in Paris, has frequented by all sorts. This gathering place *par excellence* is here turned into a place of absence and loneliness.

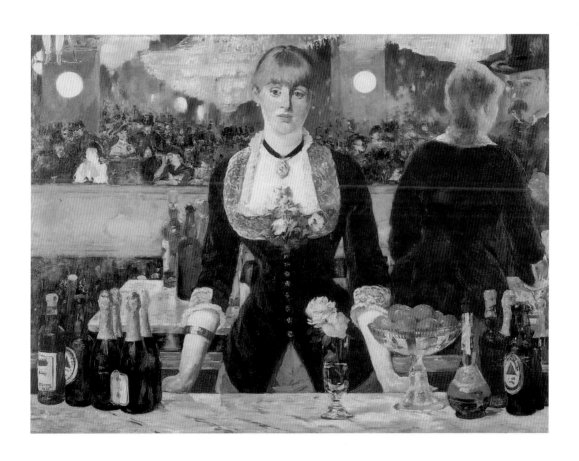

Appendix

Chronological Table

	Manet's Life	Historical and Artistic Events
1832	Born to a bourgeois family in Paris.	Poland becomes a Russian province. Mazzini founds the "Young Italy" society in Marseille.
1839	Enters Collége Rollin, where he befriends Antonin Proust.	
1848	Leaves as navy cadet on commercial steam ship.	Revolutions and uprisings throughout Europe. In Italy, the First War of Independence starts. The Manifesto of the Communist Party appears in London.
1849	Fails the competition for navy officers and his father allows him to concentrate on painting.	Repressions throughout Europe. In Italy, the first War of Independence ends.
1850	Attends the studio of painter Thomas Couture.	
1852		Louis Napoleon declares himself emperor.
1856	Leaves Couture's studio and opens a studio with Albert de Balleroy, a painter of hunting scenes.	Paris Conference on the Italian question.
1857	Meets Fantin-Latour.	French expansion in Algeria.
1858	Couture's negative opinion of Manet's *The Absinthe Drinker* marks a definitive break between the two.	French-English expedition in China.
1860	Meets Berthe Morisot, a talented young painter who becomes his student.	"Expedition of the Thousand" in Italy. Baudelaire is rejected by the Académie Française.
1861	Meets Degas. The Salon accepts *The Guitarist*.	The American Civil War begins. Proclamation of the united Kingdom of Italy.
1862	Meets Victorine-Luise Meurent, who poses for some of his paintings. Paints several Spanish-themed works, including *Lola de Valence*.	Slavery abolished in the United States. Hugo publishes *Les Misérables*. Cézanne quits his bank job and starts painting. Monet works in The Hague.
1863	Paints *Le déjeuner sur l'herbe*, which the Salon rejects. The piece is exhibited at the Salon des Refusés and raises a scandal. Baudelaire defends him. Marries Suzanne Leenhoff.	Battle of Gettysburg, between American Civil and Confederate armies. Manet, Pissarro, Jongkind, Guillaumin, Whistler, and Cézanne exhibit at the Salon des Refusés; Monet works in Fontainebleau.
1864	Paints the naval conflict between the *Kearsarge* and *Alabama*, an episode of the American Civil War that took place off the coast of Cherbourg.	Recognition of right to strike in France. Cézanne is rejected from the Salon. Leo Tolstoy writes *War and Peace*.

	Manet's Life	Historical and Artistic Events
1865	Exhibits *Olympia* at the Salon, stirring major controversy. Goes to Spain and befriends Théodore Duret in Madrid.	Assassination of Abraham Lincoln. Proudhon dies and his *The Principle of Art* is published posthumously.
1866	The Salon rejects two works presented by Manet, *Le Fifre* and *The Tragic Actor*.	War of Prussia and Italy against Austria. Zola writes *Mon Salon*, dedicated to Cézanne.
1867	Manet's works are rejected from the Universal Exposition. Zola vigorously defends him. He organizes an individual show that is harshly criticized.	Mexican Revolution. Marx publishes *Das Kapital*. Universal Exposition in Paris, with individual pavilion by Courbet. Ingres dies.
1868	Paints Émile Zola's portrait. Paints *Luncheon in the Studio*. Paints a portrait of his friend Duret.	Zola praises Manet and Pissarro; Cézanne is rejected from the Salon. Gauguin joins the merchant navy.
1869	Goes to London. Meets Eva Gonzales.	Suez Canal opens.
1870	Lightly injures critic Duranty in a duel. Fantin-Latour portrays him in his *Atelier aux Batignolles*, with Zola, Bazille, Monet, and Astruc.	The Franco-Prussian war breaks out on July 18. The Third Republic is proclaimed on September 4. Courbet and Daumier refuse the Legion of Honor.
1871	Leaves Paris shortly before the fall of the city. In his absence, he is elected to the federation of artists of the Commune.	January: armistice of France with Germany. Insurrection in Paris; the Commune is founded, lasting from March 18 to May 29.
1872	Achieves moderate commercial success. Portrays Morisot often. Goes to Holland with his wife.	Pissarro sets up in Pontoise and Monet in Argenteuil.
1873	Achieves considerable success at the Salon with *Le Bon Bock*.	Death of Napoleon III. Nietzsche publishes *The Birth of Tragedy*.
1877	First naturalistic work, *Nanà*, rejected from Salon.	Third Impressionist Exhibition. Death of Courbet. Thomas Edison invents the phonograph.
1879	Paints portrait of his friend, Antonin Proust. Goes to Bellevue for health treatments. Leg pains worsen.	Pasteur discovers rabies vaccine. Invention of electric light bulb (Edison).
1881	Receives important recognition at Salon, again stirring major controversy. Named knight of the Legion of Honor.	Czar Alexander II is killed. French protectorate in Tunisia. Verga writes *I Malavoglia*; D'Annunzio writes *Canto novo*; Fogazzaro writes *Malombra*.
1883	Dies on April 30.	Karl Marx and Richard Wagner die. First voyage of the Orient Express.

171

Geographical Locations of the Paintings

in public collections

Brazil

Portrait of Marcellin
Desboutin
Oil on canvas, 192 x 128 cm
São Paulo, Museu de Arte
1875

France

Autumn: Portrait of Méry
Laurent
Oil on canvas, 73 x 51 cm
Nancy, Musée
des Beaux-Arts
1881

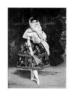

Lola de Valence
Oil on canvas,123 x 92 cm
Paris, Musée d'Orsay
1862

Le déjeuner sur l'herbe
Oil on canvas, 208 x 264 cm
Paris, Musée d'Orsay
1863

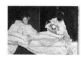

Olympia
Oil on canvas, 130.5 x 190 cm
Paris, Musée d'Orsay
1863

Vase of Peonies
on a Pedestal
Oil on canvas, 93.2 x 70.2 cm
Paris, Musée d'Orsay
1864

Branch of White Peonies
with Pruning Shears
Oil on canvas, 31 x 46.5 cm
Paris, Musée d'Orsay
1864 (?)

Fruit on a Table
Oil on canvas, 45 x 73.5 cm
Paris, Musée d'Orsay
1864

Angelina
Oil on canvas, 92 x 72 cm
Paris, Musée d'Orsay
1865

France

Reading
Oil on canvas, 61 x 74 cm
Paris, Musée d'Orsay
1865–1873 (?)

Le Fifre (The Fifer)
Oil on canvas, 160 x 98 cm
Paris, Musée d'Orsay
1866

Portrait of Émile Zola
Oil on canvas, 146 x 114 cm
Paris, Musée d'Orsay
1868

Portrait of Théodore Duret
Oil on canvas, 43 x 35 cm
Paris, Musée du Petit Palais
1868

The Balcony
Oil on canvas, 169 x 125 cm
Paris, Musée d'Orsay
1868–1869

*Berthe Morisot
with a Fan*
Oil on canvas, 60 x 45 cm
Paris, Musée d'Orsay
1872

On the Beach
Oil on canvas, 59.6 x 73.2 cm
Paris, Musée d'Orsay
1873

Woman with Fans
Oil on canvas, 113 x 166 cm
Paris, Musée d'Orsay
1873–1874

*Madame Manet
on a Blue Sofa*
Pastel on paper mounted
on canvas, 50.5 x 61 cm
Paris, Musée du Louvre,
Cabinet des Dessins
1874

*Portrait of Stéphane
Mallarmé*
Oil on canvas, 27 x 36 cm
Paris, Musée d'Orsay
1876

France

Blonde with Bare Breasts
Oil on canvas, 62 x 51.5 cm
Paris, Musée d'Orsay
1878 (?)

The Waitress
Oil on canvas, 77.5 x 65 cm
Paris, Musée d'Orsay
1879

The Asparagus
Oil on canvas, 16 x 21 cm
Paris, Musée d'Orsay
1880

The Viennese (Portrait of Irma Brunner)
Pastel on paper,
54 x 46 cm
Paris, Musée d'Orsay
1881

Argenteuil
Oil on canvas, 149 x 115 cm
Tournai, Musée
des Beaux-Arts
1874

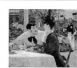

At Père Lathuille's
Oil on canvas, 93 x 112 cm
Tournai, Musée
des Beaux-Arts
1879

Germany

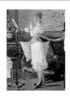

Nanà
Oil on canvas, 150 x 116 cm
Hamburg, Kunsthalle
1877

In the Conservatory
Oil on canvas, 115 x 150 cm
Berlin, Nationalgalerie
1879

Portrait of Zacharie Astruc
Oil on canvas, 90 x 116 cm
Bremen, Kunsthalle
1866

The Execution of Emperior Maximilian
Oil on canvas, 252 x 305 cm
Mannheim, Kunsthalle
1868

| **Germany** | 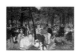 | *Luncheon in the Studio*
Oil on canvas, 118 x 153 cm
Munich, Neue Pinakothek
1868 | | *Monet Painting*
in His Floating Studio
Oil on canvas, 81 x 100 cm
Munich, Neue Pinakothek
1874 |

| **Great Britain** | | *Music in the*
Tuileries Gardens
Oil on canvas, 76 x 118 cm
London, National Gallery
1862 | 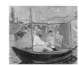 | *A Bar at the Folies-Bergère*
Oil on canvas, 96 x 130 cm
London, Courtauld Institute
Galleries
1881–1882 |

| **Russia** | 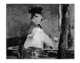 | *The Tavern – La Guinguette*
Oil on canvas, 73 x 91 cm
Moscow, Pushkin Museum
1878 |

| **Switzerland** | | *The Escape*
of Henri Rochefort
Oil on canvas, 146 x 116 cm
Zurich, Kunsthaus
1881 |

| **USA** | | *The Street Singer*
Oil on canvas, 175 x 118.5 cm
Boston, Museum
of Fine Arts
c.1862 | | *Skating*
Oil on canvas, 92.5 x 72 cm
Cambridge (Mass.), Fogg
Art Museum
1877 |

Christ Mocked
Oil on canvas,
191.5 x 148.3 cm
Chicago, The Art Institute
1865

Races at Longchamp
Oil on canvas, 43.9 x 84.5 cm
Chicago, The Art Institute
1867 (?)

Le Bon Bock
Oil on canvas, 94 x 82 cm
Philadelphia, Museum of Art
1873

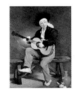

The Guitarist
Oil on canvas,
cm 147.3 x 114.3 cm
New York, The Metropolitan
Museum of Art
1860

*Mademoiselle Victorine
Meurent in the Costume
of an Espada*
Oil on canvas,
165.1 x 127.6 cm
New York, The Metropolitan
Museum of Art, 1862

Dead Christ and the Angels
Oil on canvas, 179 x 150 cm
New York, The Metropolitan
Museum of Art
1864

Woman with Parrot
Oil on canvas, 185 x 128 cm
New York, The Metropolitan
Museum of Art
1866

In the Boat
Oil on canvas,
97.2 x 130.2 cm
New York, The Metropolitan
Museum of Art
1874

Self-portrait
Oil on canvas, 83 x 67 cm
New York, Private collection
c. 1879

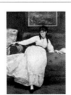

*Repose (Portrait of Berthe
Morisot)*
Oil on canvas, 148 x 113 cm
Providence, Museum of the
Rhode Island School of Design
1870

USA

Dead Toreador
Oil on canvas,
75.9 x 153.3 cm
Washington, National
Gallery of Art
1864–1865 (?)

The Railway
Oil on canvas, 93 x 114 cm
Washington, National
Gallery of Art
1872–1873

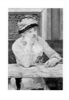

The Plum
Oil on canvas, 73.6 x 50.2 cm
Washington, National Gallery
of Art
1877–1878

An excerpt from the preface of Émile Zola's His Masterpiece (L'Œuvre), translated by E. A. Vizetelly.

"His Masterpiece," which in the original French bears the title of *L'Œuvre*, is a strikingly accurate story of artistic life in Paris during the latter years of the Second Empire. Amusing at times, extremely pathetic and even painful at others, it not only contributes a necessary element to the Rougon-Macquart series of novels—a series illustrative of all phases of life in France within certain dates—but it also represents a particular period of M. Zola's own career and work. Some years, indeed, before the latter had made himself known at all widely as a novelist, he had acquired among Parisian painters and sculptors considerable notoriety as a revolutionary art critic, a fervent champion of that 'Open-air' school which came into being during the Second Empire, and which found its first real master in Édouard Manet, whose then derided works are regarded, in these later days, as masterpieces. Manet died before his genius was fully recognised; still he lived long enough to reap some measure of recognition and to see his influence triumph in more than one respect among his brother artists. Indeed, few if any painters left a stronger mark on the art of the second half of the nineteenth century than he did, even though the school, which he suggested rather than established, lapsed largely into mere impressionism—a term, by the way, which he himself coined already in 1858; for it is an error to attribute it—as is often done—to his friend and junior, Claude Monet.

It was at the time of the Salon of 1866 that M. Zola, who criticised that exhibition in the *Événement* newspaper, first came to the front as an art critic, slashing out, to right and left, with all the vigour of a born combatant, and championing M. Manet—whom he did not as yet know personally—with a fervour born of the strongest convictions. He had come to the conclusion that the derided painter was being treated with injustice, and that opinion sufficed to throw him into the fray; even as, in more recent years, the belief that Captain Dreyfus was innocent impelled him in like manner to plead that unfortunate officer's cause. When M. Zola first championed Manet and his disciples he

was only twenty-six years old, yet he did not hesitate to pit himself against men who were regarded as the most eminent painters and critics of France; and although (even as in the Dreyfus case) the only immediate result of his campaign was to bring him hatred and contumely, time, which always has its revenges, has long since shown how right he was in forecasting the ultimate victory of Manet and his principal methods.

In those days M. Zola's most intimate friend— a companion of his boyhood and youth—was Paul Cézanne, a painter who developed talent as an impressionist; and the lives of Cézanne and Manet, as well as that of a certain rather dissolute engraver, who sat for the latter's famous picture *Le Bon Bock*, suggested to M. Zola the novel which he has called *L'Œuvre*. Claude Lantier, the chief character in the book, is, of course, neither Cézanne nor Manet, but from the careers of those two painters M. Zola has borrowed many little touches and incidents. The poverty which falls to Claude's lot is taken from the life of Cézanne, for Manet—the only son of a Judge—was almost wealthy. Moreover, Manet married very happily, and in no wise led the pitiful existence which in the novel is ascribed to Claude Lantier and his helpmate, Christine. The original of the latter was the poor woman who for many years shared the life of the engraver to whom I have alluded; and, in that connection, it is as well to mention that what may be called the Bennecourt episode of the novel is virtually photographed from life.

Whilst, however, Claude Lantier, the hero of *L'Œuvre*, is unlike Manet in so many respects, there is a close analogy between the artistic theories and practices of the real painter and the imaginary one. Several of Claude's pictures are Manet's, slightly modified. For instance, the former's painting, *In the Open Air*, is almost a replica or the latter's *Déjeuner sur l'Herbe* ("A Lunch on the Grass"), shown at the Salon of the Rejected in 1863. Again, many of the sayings put into Claude's mouth in the novel are really sayings of Manet's. And Claude's fate, at the end of the book, is virtually that of a moody young fellow who long assisted Manet in his studio, preparing his palette, cleaning his brushes, and so forth. This lad, whom Manet painted in *L'Enfant aux Cerises* ('The Boy with the Cherries'), had artistic aspirations of his own and, being unable to satisfy them, ended by hanging himself.

I had just a slight acquaintance with Manet, whose studio I first visited early in my youth, and though the exigencies of life led me long ago to cast aside all artistic ambition of my own, I have been for more than thirty years on friendly terms with members of the French art world. Thus it would be comparatively easy for me to identify a large number of the characters and the incidents figuring in "His Masterpiece"; but I doubt if such identification would have any particular interest for English readers. I will just mention that Mahoudeau, the sculptor, is, in a measure, Solari, another friend of M. Zola's boyhood and youth; that Fagerolles, in his main features, is Gervex; and that Bongrand is a commingling of Courbet, Cabanel and Gustave Flaubert. For instance, his so-called "Village Wedding" is suggested by Courbet's "Funeral at Ornans"; his friendship for Claude is Cabanel's friendship for Manet; whilst some of his mannerisms, such as his dislike for the praise accorded to certain of his works, are simply those of Flaubert, who (like Balzac in the case of *Eugénie Grandet*) almost invariably lost his temper if one ventured to extol *Madame Bovary* in his presence.

Extracts from Pierre Courthion and Pierre Cailler's volume Portrait of Manet by Himself and His Contemporaries, *translated by Michael Ross.*

To Antonin Proust, on his portrait on view in the 1880 Salon

My dear Friend,
Your picture has been on exhibition in the Salon for the last three weeks—badly hung near a door, on a divided panel, and even worse criticized. But it seems to be my lot to be slanged and I accept it philosophically.

However, you have no idea how difficult it is, my dear friend, to place a single figure on a canvas, and to concentrate all the interest on that one and on-

ly figure without its becoming lifeless and unsubstantial. Compared with this, it's child's play to paint two figures together who act as foils to each other.

Ah! That portrait with the hat, in which I'm told everything was blue. All right! I'm ready for them. Personally, I can't see it—later, after I'm gone, it will be admitted that I did observe things accurately with a clear mind.

Your portrait is painted with the utmost sincerity possible. I remember, as if it were only yesterday, the quick and simple way I treated the glove you're holding in your bare hand and how, when you said to me at the moment, "*Please*, not another stroke," I felt in complete sympathy with you and could have hugged you.

Oh, how I hope that later on, there will not be some stupid idea of hanging this picture in a public collection. I've always disliked intensely this idea of crowding works of art together so that you can't even see daylight between them, in the way novelties are displayed in fashionable shops. Anyway, "He who lives will see,"—it's in the hands of fate.

LE SALON DES REFUSÉS [1]

The exhibition of paintings rejected by the Salon was held in the same Palais as that in which the accepted paintings were being shown. It was possible to go from one exhibition to the other by passing through a small turnstile, and it came as a great surprise to see the list of people who hurried to visit it. This exhibition of rejected artists was a shrewd blow against the rejectors.

"One enters the annexe with a smile,' wrote Monsieur de Cupidon—*alias* Charles Mongelet—'but one leaves it serious, worried, and a little unsure of oneself...."

Manet was one of the artists who attracted attention, although among the first-comers he certainly had no adherents. His paintings were surrounded by the works of Lavieille, Bracquemond, Legros, Jongkind, Whistler, Harpignies, Lemarié, Planet, Saint-Marcel, and Sutter.

Le Déjeuner sur l'herbe and *Le Bain* were very much admired, and enlightened visitors to the exhibition payed them the tribute which the Academy

had begrudged. Feeling ran very high and extended even as far as the Tuileries. Napoléon III and his wife provoked a scandal by their appearance in this den of revolutionaries, or rather—for the most part—of rebels. The crowd, goggle-eyed, followed in the wake of Their Majesties and for several weeks there was a continuous and undiminishing throng of people visiting the exhibition. (*Edmond Bazire: Manet, 1884*)

THE MARRIAGE OF THE PAINTER

... Manet has just announced the most unexpected news to me. He's leaving this evening for Holland, from where he will bring back *his wife*! He has some excuse however, because it seems that his wife is not only beautiful, but very good and also a very talented musician. So many treasures, all combined in one person! Don't you think it's monstrous? [2]

SALON OF 1864

Monsieur Manet has the talent of a Magician; his color is luminous and brilliant, like that of his favourite masters, Velazquez and Goya. It is of them that he was thinking when he designed and painted his arena. In his second picture, *Les Anges au Tombeau du Christ*, he has imitated with equal force another Spanish master, El Greco, which is a challenge to the bashful lovers of discreet and tidy painting. This Christ, seated like any ordinary person, is seen full face with both arms pressed against his body. It is a terrifying picture to look at. Is he perhaps about to rise from the dead under the wings of the two helping angels? And oh, what strange wings they are—wings from another world, more intensely blue than the deepest sky! No terrestrial birds have such plumage; but maybe angels, the birds of heaven, wear such colours, and a public, which has never seen an angel, has no right to scoff.... The colour of angels is not a subject for discussion. But I feel that this awesome Christ and these angels with wings of Prussian blue, don't care a jot about people who say, "But that's impossible! It's an aberration!" It was a very distinguished lady who thus apostrophized Monsieur Manet's poor Christ, who hangs exposed to the ridicule of the female Pharisees

of Paris. But nothing can alter the fact that the white tones of the shroud and the colour of the flesh are extremely accurately observed, and that the broad and free treatment of the modeling, particularly in Christ's right arm, and in the foreshortening of the legs, remind one of some of the greatest masterpieces—Tuben's *Dead Christ* and *Christ on the Straw* in the Antwerp Museum, for example, and even of certain Christs by Annibale Caracci. The comparison is very marked, but it is to El Greco, the student of Titian and the master of Luis Tristan, who in his turn became the master of Velazquez, that Monsieur Manet's *Christ* bears the closest resemblance.

Enough has been said about Manet's eccentricities, which conceal a real painter, whose works, one day perhaps, will be acclaimed by the public. Remember how Eugène Delacroix began his career; remember his success at the Universal Exhibition of 1835, and the sale of his works—after he was dead!

(*Article by Thoré-Bürger in* L'Indépendence Belge, *15 June 1864*)

LETTER FROM BAUDELAIRE TO THORÉ-BÜRGER
… I don't know if after all these years you still remember me and our former conversations. Time passes so quickly. I read your article very diligently and I would like to thank you for the pleasure you have given me by coming to the defence of my friend, Édouard Manet, and for according him *a little* justice. But there are one or two small points in your article which need to be amended.

Monsieur Manet, who is credited with being mad and hot-tempered, is quite simply, a very loyal and unpretentious man, who does everything possible to behave rationally, but who unfortunately has been labelled as a romantic since birth. The word *imitate* is not the right one. Monsieur Manet has never seen a Goya; Monsieur Manet has never seen an El Greco; Monsieur Manet has never seen the Galerie Pourtalès. This may seem incredible—but it is a fact. I, myself, have been absolutely amazed by these extraordinary coincidences.

At the time when we were the happy owners of this marvellous Spanish Museum (which the stupid French Republic, with its *improper* respect for property, has handed back to the Princes of Orléans), Monsieur Manet was serving on board ship. He has been told so often of his imitations of Goya that he is now making some arrangements to see some Goya paintings. It is true, he has seen some Velazquez paintings—I don't know where. Do you doubt my word? Do you question the fact that astonishing parallels can exist in nature? Very well! *I* am accused of imitating Edgar Poe! Do you know why I have so patiently studied Poe? Because he resembles *me*! The first time I opened a book by Poe I was astonished and delighted to find, not only plots dreamed up by me, but whole phrases that UI had composed, which *he* had written twenty years before. *Et nunc erudimini, vos qui judicatis!*

Don't be cross, but keep a happy memory of me in a corner of your heart. I'll thank you every time you try to be of service to Manet.

I'm taking this scribble to Monsieur Bérardi for him to give to you. I have the courage, or rather, the absolute cynicism of my convictions. Quote my letter or some part of it; I've told you nothing but the truth. (*Reply to the article quoted above, 1864*)

MY PORTRAIT BY ÉDOUARD MANET (MEMORIES OF THE SITTING) BY ÉMILE ZOLA
I have just read, in the last edition of *L'Artiste*, these words by Monsieur Arsène Houssaye: "Monsieur Manet could be and outstanding artist if he had 'dexterity?….. It is not enough to have a thoughtful brow, or an observant eye: one must have a hand that speaks!"

For me, here is an admission well worth picking on. It is with pleasure that I read this statement by this poet of dainty trifles, this novelist of fine ladies, to the effect that Édouard Manet has a thoughtful brow and an observant eye and could be an outstanding artist. I know that he qualifies his statement, but this reservation is quite understandable. Monsieur Arsène Houssaye, the gallant eighteenth-century epicure, who is misleading us today with his prose and analyses, would like to add a little powder and patches to the artist's sober and precise talent.

I will reply to the poet: "Don't insist too much that the original and very personal master of whom you speak should be more dexterous than he is. Look at those *trompe-l'œil* pictures… in the Salon. Our artists are too clever by half; they play like children with puerile difficulties. If I were a great judge, I would have their wrists cut off and open their minds and brains with pincers."

However, it is not only Monsieur Arsène Houssaye who dares admit today that there *is* a talent in the work of Édouard Manet.

Lat year, at the time of the artist's private exhibition, I read criticisms in several newspapers, praising a large number of his works. The inevitable reaction which I forecast in 1866 [on 4 and 7 May in *L'Evénement*] is slowly coming about. The public is becoming used to his work; the critics are calming down and have agreed to open their eyes; success is on its way.

But this year it is especially among his colleagues that Manet has met with increasing understanding. I don't think I have the right to quote here the names of the painters who have so heartily and honestly admired the portrait exhibited by the young master [3]. But these painters are numerous and are amongst the best. As far as the public is concerned, it still does not understand, but it no longer laughs. I was amused last Sunday to study the expressions of the people who stopped to look at the pictures of Édouard Manet. Sunday is the day set aside for the real mob, the uninformed, whose artistic taste has still to be completely developed.

I saw people arriving who had come with the resolve to be slightly amused. They remained with raised eyes, open-mouthed, completely put out, unable to raise the vestige of a smile. Unknown to them, their outlook had become acclimatized. Manet's originality, which had once seemed to them so prodigiously comic, now occasions them no more astonishment than that experienced by a child confronted by an unknown spectacle.

Others enter the gallery, glance along the walls and are attracted by the strange elegance of the artist's work. When they see the name Manet they try to force a laugh. But the canvases are there, clear and luminous, and seem to look down on them

proudly and disdainfully. They go away, ill at ease, not knowing any more what to think; moved, in spite of themselves by the sincerity of his talent, prepared to admire it in the years to follow.

From my point of view, the success of Édouard Manet is assured. I never dared dream that it would be so rapid and deserving. It is singularly difficult to make the shrewdest people in the world admit a mistake. In France, a man whom ignorance has made a figure of fun is often condemned to live and die a figure of fun. You will see in the minor newspapers, for a long time to come, that there will still be jokes at the expense of the painter of *Olympia*. But from now on intelligent people have been won over, and as a result the mob will follow. The artist's two pictures are unfortunately very badly hung in corners, very high, next to the doors. In order to see and judge them satisfactorily they should have been hung "on the line," under the nose of the public which likes to look at pictures closely. I like to think that it is only because of an unfortunate chance that these remarkable pictures have been relegated where they are. However, although they are badly hung you can see them from a distance; and placed as they are among trifles and surrounded by sentimental trash, they stand out a mile.

I will not speak of the picture entitled *Une Jeune Dame*. It is already known to the public and was seen at the artist's private exhibition. I would only advise those clever gentlemen who dress up their dolls in dresses copied from fashion plates, to go and look at the dress which this young woman is wearing; it's true you cannot tell the grain of the material, nor count the stitches; but it hangs admirably on the living body. It is related to that supple cloth, fatly painted, which the old masters cast over the shoulders of their models. Today, artists provide for themselves at a first-rate dress-maker, like little ladies.

As for the other picture…

One of my friends asked me the other day if I would talk about this picture which is a portrait of myself. "Why not?" I answered, "I would like to have ten columns of newsprint to proclaim what I quietly thought during the sittings, while I watched

Edouard Manet struggle foot by foot with Nature. Do you imagine that I have so little dignity that I take pleasure in entertaining people with my own physiognomy? Naturally, I will speak of this picture, and any ill-natured people who find it a subject for witticism are merely fools."

I recall the long hours I sat for him. While my limbs became numbed from not moving, and my eyes were tired from looking straight ahead, the same deep and quiet thoughts continually passed through my mind.

The nonsense that is spread abroad, the lies and platitudes of this and that, all this human hubbub, which flows by uselessly, like so much dirty water, seemed far, far away. It seemed to me that I was outside this world, in an atmosphere of truth and justice and I was filled with a disdainful pity for the poor wretches who were floundering about below.

From time to time, as I posed, half-asleep, I looked at the artist standing at his easel, with features drawn, clear-eyed, engrossed in his work. He had forgotten me, he no longer knew I was there, he simply copied me, as if I were some human beast, with a concentration and artistic integrity that I have seen nowhere else. And then I thought of the slovenly dauber of legend, of this Manet who was a figment of the imagination of caricaturists, who painted cats as a leg-pull. It must be admitted that wit is often incredibly stupid.

I thought for hours on end of the fate of individual artists which forces them to live apart in the loneliness of their art. Around me, forceful and characteristic canvases, which the public had chosen not to understand, hung on the walls of the studio. It is enough to be different from other people, to think one's own thoughts, to be talented, to be regarded as a monster. You are accused of ignoring your art, of laughing at common sense, simply because your eye and inclinations lead you to individual results. As soon as you no longer follow in the swim of the commonplace, fools stone you, treating you either as mad or arrogant. It was while pondering these ideas that I saw the canvas "fill up." What, personally, astonished me, was the extreme conscientiousness of the artist.

Often, when he was coping with a detail of secondary importance, I wanted to stop posing and give him the bad advice that he should "invent."

"No," he answered me, "I can do nothing without Nature. I do not know how to invent. As much as I have wanted to paint in accordance with the lessons I have been taught, I have never produced anything worth while. If I am worth something today, it is due to exact interpretation and faithful analysis."

There lies all his talent. Before anything else, he is a naturalist. His eye sees and renders objects with elegant simplicity. I know I won't be able to make the blind like his pictures; but real artists will understand me when I speak of the slightly bitter charm of his works. The colour of it is intense and extremely harmonious. And this, mark you, is the picture by a man who is accused of being able neither to paint nor draw. I defy any other portrait painter to place a figure in an interior so powerfully, and yet avoid making the surrounding still-life objects conflict with the head.

This portrait is a combination of difficulties overcome. From the frames in the background, from the delightful Japanese screen which stands on the left, right up to the very smallest details of the figure, everything holds together in masterly, clear, striking tones, so realistic that the eye forgets the heaps of objects and sees simply one harmonious whole.

I do not speak of the still-lifes—the accessories and the books scattered on the table. Manet is a pastmaster where this is concerned. But I particularly draw your attention to the hand resting on the model's knee. It is a marvel of skill. In short, here is skin, but real skin without ridiculous *trompe-l'œil*. Of all parts of the picture had been worked on as much as the hand, the mob itself would have acclaimed it as a masterpiece. (*Émile Zola:* L'Événement Illustré, *10 May 1868*)

THE TRIUMPH OF MANET, BY PAUL VALERY
"Manet et manebit"
Manet, still seduced by picturesque foreigners, still sacrificing to toreadors, guitars and mantillas, but already half-conquered by subjects nearer home and

models drawn from the streets, presented a problem to Baudelaire which was not unlike Baudelaire's own: that is to say, of an artists who is prey to various rival temptations but who, moreover, is still capable of being himself in several admirable different styles.

It is enough to turn over the pages of the this collection of the *Fleurs du Mal*, to notice this significant and, as it were, concentrated diversity of subjects and poems and to find here an affinity with the diversity of motifs which are listed in the catalogue of Manet's work, and to realize that both poet and painter suffered from the same anxieties.

The man who wrote *Bénédiction, Les Tableaux Parisiens, Les Bijoux* and *Le Vin des Chiffoniers* must have had something profoundly in common with the man who painted by turns *Le Christ aux Anges* and *Olympia, Lola* and *Le Buveur d'Absinthe*.

A few remarks will suffice to prove the strength of this relationship. Both were the offspring of similar old Parisian bourgeois families; they both possessed that very rare combination of refined elegance and an unusual keenness for work.

Furthermore, they both spurned to employ effects which were not obtained with a clear conscience or by other means than their own talents. This is what makes for "purity" both in painting and in poetry. They did not indulge in conjecture concerning "sentiment," nor introduce "ideas," without having cunningly and subtly organized "feeling." To sum up, their object was to pursue and recapture "charm"—the supreme object in art—and I use the word here in its fullest meaning.

This is what I think of when those delightful verses come to my mind, verses which were regarded as equivocal by the perverse and which alarmed the Palais—I refer to the famous "jewel, rose and black" which Baudelaire offered to "Lola de Valence." This mysterious jewel seems to me to be less suitable for the solid and robust dancer, who, weighed down with a rich and heavy skirt, but sure of the suppleness of her muscles, waits superb in the shadow of the wings for the signal to leap forth into the irregular movement of her frenzied dance, than for the cold, nude *Olympia*, monster of profane love, attended by her Negress.

Olympia shocks, she overawes, she is exultant. She is scandalous, idolatrous, the lewd force and presentment of a wretched arcana of society. Her head is empty—a black velvet band isolates it from her essential body. The purity of a perfect line encloses this most impure of creatures, whose profession forces her to remain forever in a blissful ignorance of modesty. An animal Vestal, vowed to complete nakedness, she forces us to reflect on all the primitive barbarism and bestial ritual which is hidden and preserved in the habits and activities of prostitution in our big cities.

… That Zola and Mallarmé, at the tow extremes of literature, should both have been so enamoured of his art, must have been a great source of pride to him. The one had a simple belief in things as they are—nothing was too solid, too weighty, or too forceful for him: in literature he believed that nothing must be left to the imagination. He was convinced of the efficacy of prose to depict—almost to recreate—the world and mankind, cities, customs, passions and machines….

Relying on the *mass effect* of quantities of detail and countless pages and volumes, he hoped by means of the novel to influence society and its laws. Because his ambition was to preach a lesson rather than to entertain his readers, his criticisms, like political articles, are filled with sarcasm, bitterness and threats. In a word, Zola was one of those artists who appeal to average opinion and who base their work on statistics. But there are some excellent passages in his vast output.

The other, Stéphane Mallarmé, was the exact opposite. He is essentially selective, but to be over-careful in choice of phrase and construction is, finally, to be over-selective in readers. Deeply anxious to achieve perfection of style and quite regardless of public success, he scarcely wrote at all.

Far from wanting to bring people and things to life by means of literary composition and laborious description, he merely regarded the world as a means to an end to produce poetry. He saw the world in terms of a beautiful book….

Thus Manet's triumph, even during his lifetime, was thanks to these men whose art was so diametri-

cally opposed, who even held antagonistic views, but who loved and influenced his work….

While, for example, Zola admired Manet's "realism"—the acute and forceful way in which he observed "truth"—Mallarmé, on the contrary, enjoyed the marvel of his sensual and *spirituel* transmutation of things on to canvas. Quite apart from this, he found in Manet an extremely charming personality. I must add, however, that being the perceptive critic that he was, Mallarmé appreciated all that is most poetic and… moving in Zola's work….

I rate nothing higher in Manet's work than a certain portrait of Berthe Morisot, dated 1872.

The figure, a little under life-size, is painted against a light, neutral-colored grey curtain. But what struck me most was the *black*—a black that only belongs to Manet—the black of a mourning hat, and the strings of this little bonnet, interwoven with locks of chestnut hair heightened by rose-colored lights.

Attached to it is a broad black ribbon which passes over the left ear and is carelessly wound round the neck. The black mantle over her shoulders allows a glimpse of pale flesh and the ruffles of a white linen collar.

These striking black passages frame a face whose over-large dark eyes give it a distraite and faraway look. It is freely painted and gives an impression of facility, obedient to the suppleness of his brush; the shadows on the face are so transparent, and the lights so delicate, that I am reminded of that head of a young woman by Vermeer in the Hague. But in Manet's portrait the execution seems more spontaneous, more "immediate." The modern man works quickly, he wants to carry out his work before the first impression dies.

(*Paul Valéry, of the Académie Française: Extracts from the Preface to the Catalogue of the Manet Exhibition, Musée de l'Orangerie, 1932*)

[1] All the works submitted by Manet to the jury of the Salon, which was opened on 1 May 1863 in the Palais de l'Industrie, were rejected. But the number and importance of artists whose work had been rejected that year was so considerable, that Napoléon III ordered that their works should be shown. The Salon had to bow before his orders and the pictures were displayed in some adjoining galleries in the Palais de l'Industrie to which the public was admitted on a small admission fee.

[2] When the artist was twenty years of age, in 1852, Suzanne Leenhoff had been appointed his piano teacher. In the same year she gave birth to a boy to whom Manet became godfather at a Protestant christening three years later. To quote Théodore Duret: "In October 1863, a year after the death of his father, her regularized their union. Suzanne Leenhoff belonged to a family devoted to art; one of her brothers, Ferdinand, was a sculptor and engraver; she herself was a pianist, and although she only played among friends, she devoted herself to music with enthusiasm. In her, Manet found a woman of artistic taste, able to understand him and to give him that support and encouragement which helped him better withstand the attacks made upon him. His father had died in 1862, leaving his fortune to be divided among his three sons, sufficient to support them in comfort. Manet thus found himself in a privileged position among artists. He was able to live without the necessity of selling his pictures, which nobody in those early days would have bought at any price, and he was able to set aside enough to provide for the necessary expenses for a studio and models."

[3] *Portrait d'Émile Zola* (1868).

*E*xcerpts from *Théodore Duret's* Manet and the French Impressionists.

Having overcome the opposition of his family and obtained permission to follow his own vocation, Manet chose Thomas Couture for his master, with his father's acquiescence, and entered his studio.

No painter ever strove harder to acquire a mastery of his craft than Manet. Finding himself at last inside a studio, he set himself to work diligently, and, at the beginning, at all events, endeavored to make the most of the teaching that was to be had there. But Manet was possessed of a strong sense of individuality, and was dominated by the impulse which urges all men of original character to follow an independent course. The very effort which he made to give his own latent talent expression, rendered him somewhat refractory pupil, perpetually at loggerheads with his master. The two were of entirely different

character. M. Antonin Proust, who was Manet's friend at the Collège Rollin, and afterwards his fellow-pupil in Couture's studio, has given some account in the *Revue Blanche* of the relations that existed between master and pupil. It is a long story of constant collisions, of quarrels followed by reconciliations, but, as the discussions sprung from a fundamental difference, they inevitably broke out again and ended in a definite hostility. Indeed, the youth whom Couture had taken into his studio was destined to be the man who, more than any other, was to undermine that conventional sort of art of which Couture was one of the chief apostles. In taking Manet into his studio, he had let the wolf into the sheepfold. A final rupture between the two men was inevitable, for the one instinctively attacked what the other defended; and as his judgment matured and became conscious of itself, Manet devoted himself to undoing his master's work....

Manet was the [arche]type of the perfect Frenchman. I have heard Fantin-Latour say: "I put him into my *Hommage à Delacroix* with his true Gallic head." Painters judge by the eye, and Fantin's judgment was not mistaken. Manet was fair, active, of medium height. His face was open and expressive; he could never mask his feelings; the mobility of his features betrayed him. He used to accompany his speech with gesture, and in uttering his thoughts a kind of countenance lent emphasis to his meaning. He was all exuberance and impetuosity. His first impressions, whether of vision or judgment, were astonishingly accurate. Intuition revealed to him what others only discover after reflection. He had a brilliant wit; his sayings could be very bitter, but at the same time there was a large geniality, sometimes even a kind of artlessness, in his manner. He was extremely sensitive to the respect or disrespect which was shown to him. He was never able to accustom himself to treat the insults which were heaped upon him as an artist with indifference; he felt them as acutely at the end of his career as at the beginning. At first he used to revile those who reviled him. In his personal relations with other men he was equally susceptible. He fought a duel with Duranty because of a few stinging words followed by a blow. But with this susceptibility and promptness to take offence he never harboured any rancor. His heart was as large as his intelligence. As a friend he was a staunch as he was delightful.

An excerpt from George Mauner's Manet Peintre-Philosophe: a Study of the Painter's Themes.

Of all Manet's major works of the early 1860's, the best-known one with a division into two parts, one bright and the other dark, is *Olympia*. It has been agreed that the artist, in his subject and composition, depended on Titian's *Venus of Urbino*; of all the possible reclining Venus prototypes available to him, the choice of this one may well have been determined by the decision of Titian's canvas into two distinct parts by means of a sharp vertical line that separated the spatial areas of the work. This division, which Manet adapted to his own purposes, plus the subject of a reclining nude with an animal at her feet, is sufficient to recall Titian's painting, although the two works are utterly different in the most essential ways. The languorous Venus and the sensual climate she establishes are features entirely alien to the rigid Olympia, who conveys instead a spirit of modern Parisian intelligence. This is a nimble woman, frozen in a moment of inactivity. Her nervousness is projected by the tension of her pose, an original solution to the problem of suggesting these characteristic unstable qualities in a timeless way, so that the evocation of the traditional and symbolic goddess of love is not lost in a quintessentially modern image. In choosing to evoke a Venus by Titian, Manet may also have been conscious of challenging Baudelaire. In his article on the painter of modern life, the poet had specifically stated that any modern artist who bases his Venuses on those of Raphael and Titian is bound to produce a false or ambiguous work. *Le Déjeuner sur l'herbe* and *Olympia* were painted in the same year; in the one Manet had looked to Raphael for his nude, and in the other he had turned to Titian. Both works were modern and viable. It could be done.

But both works were also deeply unsettling, and this, in addition to certain technical devices (the flesh tone of *Olympia*, the spatial ambiguities of the *Déjeuner*), was perhaps the result of Manet's having reversed accepted practice in his references to time. Whereas Couture, like David had in good academic practice painted a Roman scene with the purpose of making a critical comment on modern life, Manet depicted scenes of modern life with reference to the pre-existence of their essential significance. There is another important difference, and that is Manet's refusal to make moral judgments. There is little doubt that *Olympia* is a courtesan, but whereas to Couture modern morals suggested the Roman orgy, which he painted and condemned through the presence of the two Stoic philosophers who observe the festivities, to Manet the prostitute of his own day recalled a divine prototype. She is the reduction to a symbol of the appeal to one side of man's nature. In this we have a clear demonstration of Manet's proclaimed scorn for history painting. The event in itself was of no interest to him as an artist, unless it could be made to illuminate the unchanging, fundamental truths, and these could be understood only by the direct experience available in one's own time and place. Modernity had to provide the motifs for the artist. Historical images that were heroic or moralizing had no place in Manet's conception of art. He refused to judge modern life—or ancient life either, for that matter. He viewed no one period as wither superior or inferior to another. This does not mean that he was disinterested in contemporary events of a historical nature, as *L'Exécution de l'Empereur Maximilien* and the naval battle *Le Kearsarge et l'Alabama* prove. It does mean that he rejected the notion of history as a flow of events leading to new situations morally better or worse than others. At least, this seems to be true as far as his work as an artist, his means of communication with his public, was concerned. For Manet, the *peintre-philosophe*, history was a constant repetition of eternal truths appearing in an endless variety of guises—all of the experienced one appealing to the senses and fascinating to the painter. The philosopher, however, never fails to remark on the fact that an unalterable inner situation is being re-

played once more. The coolness with which his figures and situations are treated, regardless of the intensity that the scene may have had in life, is indicative only of a rejection of the notion of a moralized history. The visual sensation may always be unique, and unique each picture remains, but the historical interpretation is not, so that in Manet's art we cannot speak of a narrative at all.

While Olympia is less sensual than Titian's Venus, she is more awesome. The mood and personality of Titian's figure are relatively clear. Olympia remains a cipher. Her alert but uninformative stare, her rigid, uncompromising posture, and her starkness emphasized by strong juxtapositions of light and dark (not within an area, necessarily, but in one large area against another) constitute her uniqueness and transcend the modernity of 1863. It is, of course, the unknown, the complex human mystery at which the painter hints in this fusion of the directly given and the elusive, qualities both in his life and his own art. No doubt the frustration that gave rise to anger when the painting was shown in 1865 and that is still felt by some today is the consequence of being confronted by a mystery, presented in a forceful image of the utmost clarity.

*A*n excerpt from Jonathan Crary's Unbinding Vision: Manet and the Attentive Observer in the Late Nineteenth Century.

Manet in 1879 stands as close to a turning point in the visual status of the fashion commodity—a year or so later is when Frederic Ives patents his half-tone printing process, allowing photographs to be reproduced on the same page as typography and setting up, on a mass scale, a new virtual field of the "commodity as image" and establishing new rhythms of attentiveness which will increasingly become a form of work: work as visual consumption. In this painting [*In the Conservatory*], we have Manet elegantly disclosing what Walter Benjamin was to articulate so bluntly in the Arcades Project; in addition to providing an image of what Benjamin called "the enthronement of merchandise," the painting illustrates

Benjamin's observation that the essence of fashion "resides in its conflict with the organic. It couples the living body to the inorganic world. Against the living, fashion asserts the rights of the corpse and the sex appeal of the inorganic." Thus, despite Manet's play here with the images of adorned women as a flower among flowers, or of fashion as a blossoming forth into a luminous apparition of the new, the commodity is part of the large suffocating organization of the painting. Fashion works to bind attention onto its own pseudounity, but at the same time it is the intrinsic mobility and transience of this form that undermines Manet's attempt to integrate it into the semblance of a cohesive pictorial space and that contributes to the derangement of visual attention mapped out across its surface.

Mallarmé's *La Dernière mode*, the magazine he produced in 1874, was one of the earliest and most penetrating explorations of this new terrain of objects and events. *La Dernière mode* is a kaleidoscopic decomposition and displacement of the very objects that are evoked so glitteringly. Attention in Mallarmé, as Leo Bersani has noted, always moves away from its objects, undermining any possibility of a fully realized presence. The emerging world of fashion commodities and of life structured as consumption, at least for several months in the fall of 1874, revealed to Mallarmé a present impossible to seize hold of, an insubstantial world that seemed aligned with his own sublime disavowal of the immediate.

Manet in one sense gives a solidity and a palpable presence to what for Mallarmé remained evanescent, but even here the fashion commodity is present as a kind of vacancy, haunted by what Guy Debord describes as its inevitable displacement from the center of acclaim and the revelation of its essential poverty. Within this new system of objects, which was founded on the continual production of the new, attention, as researchers learned, was sustained and enhanced by the regular introduction of novelty. Historically, this regime of attentiveness coincides with what Nietzsche described as modern nihilism: an exhaustion of meaning, a deterioration of signs. Attention, as part of a normative account of subjectivity, comes into being only when experiences of singularity and identity are overwhelmed by equivalence and universal exchange.

Part of the precariousness of *In the Conservatory* is how it figures attentiveness not only as something constitutive of a subject within modernity but also as that which dissolves the stability and coherence of a subject position. And in a crucial sense the work, in its use of the two figures, is poised at a threshold beyond which an attentive vision would break down in a loosening of coherence and organization. Manet perhaps knew intuitively that the eye is not a fixed organ, that it is marked by polyvalence, by shifting intensities, by an indeterminate organization, and that sustained attentiveness to anything will relieve vision of its fixed character. Gilles Deleuze, writing about what he calls "the special relation between painting and hysteria," suggests that for the hysteric, objects are too present, that an excess of presence makes representation impossible, and that the painter, if not restrained, has the capacity to extricate presences from representation. For Deleuze, the classical model of painting is about warding off the hysteria that is so close to its heart.

In the Conservatory, in the ways I have indicated, thus reveals Manet (for a number of possible reasons) attempting ambivalently to reclaim some of the terms of that classical suppression and restraint. But the result is something quite different from a return to an earlier model, and I have tried to suggest the range of disjunctions within Manet's synthetic activity in this work. Perhaps the painting's most notable feature to evade the state of enclosure, of being "in the grip" or "dans la serre," is the tangled mesh of green behind the figures. Is this what also fills the other side of the room, a possible object of the woman's attention or distraction? Manet has applied the paint of the vegetation so thickly around the figures that it rises up in an encroaching ridge around them; the green is thus physically closer to our view than the figures themselves. This turbulent zone of color and proliferation exceeds its symbolic domestication and ceases to function as a part of the figure/ground relationship. It becomes the sign of a perpetual order alien to the relations of Manet has sought to freeze or stabilize around the two figures.

It is a site on which attention is enfolded into its own dissolution, in which it can pass from a bound to a mobile state. It is amid the continuity between these states that vision can become unhinged from the coordinates of its social determinants. And this is what Manet's grip can only imperfectly keep in check—an attentiveness that would lose itself outside those distinctions....

Vision, in a wide range of locations, was refigured as dynamic, temporal, and synthetic. The demise of the punctual or anchored classical observer began in the early nineteenth century, increasingly displaced by the unstable attentive subject, whose varied contours I have tried to sketch out here. It is a subject competent both to be a consumer of and an agent in the synthesis of a proliferating diversity of "reality effects," a subject who will become the object of all the industries of the image and spectacle in the twentieth century. But if the standardization and regulation of attention constitute a path into the video and cybernetic spaces of our own present, the dynamic disorder inherent in attentiveness, which Manet's work begins to disclose, embodies another path of invention, dissolution, and creative syntheses which exceeds the possibility of rationalization and control.

An excerpt from Albert Gleizes and Jean Metzinger's Cubism.

Reality is deeper than academic recipes, and more complex also. Courbet was like one who contemplates the Ocean for the first time and who, diverted by the play of the waves, does not think of the depths; we can hardly blame him, because it is to him that we owe our present joys, so subtle and so powerful.

Edouard Manet takes a higher stage. All the same, his realism is still below Ingres' idealism, and his *Olympia* is heavy next to the *Odalisque*. We love him for having transgressed the decayed rules of composition and for having diminished the value of anecdote to the extent of painting "no matter what." In that we recognize a precursor, we for whom the beauty of a work resides expressly in the work, and not in what is only pretext. Despite many things, we call Manet a realist less because he represented everyday events than because he endowed with a radiant reality many potential qualities enclosed in the most ordinary objects.

Excerpts from Arden Reed's Manet, Flaubert, and the Emergence of Modernism: Blurring Genre Boundaries *by Arden Reed. Reprinted with the permission of Cambridge University Press.*

What does it mean for me to call a painter "literary"? For one thing, Manet was intimately connected with several important writers of his day—Baudelaire, Zola, and Mallarmé—and the subject of critical studies by Zola, Mallarmé, Valéry, Malraux, and Bataille. He was fictionalized by Baudelaire, Zola, the Goncourts, and Proust, among others. Manet illustrated a number of texts, and poets composed verses to accompany his pictures. The weight of all this commerce suggests a certain resonance beyond the circumstantial between Manet and these writers. More significantly, Manet's "literariness" follows from—or else helps to explain—his relationship to the history of painting. Michael Fried demonstrated at length "the literalness and obviousness with which [Manet] often quoted earlier paintings." In borrowing the language of literary criticism—Manet "quotes" or "alludes to" Velázquez, say—art historians are in fact proposing a kind of intertextuality. In *Fishing* (1861–3), for example, Manet "cites" Annibale Carracci and Rubens in a way that a later poet might cite earlier ones, at once recalling the antecedent "figure" and revising it. Furthermore, Manet sometimes puns across the visual-verbal divide, as with the wallpaper crane in *Nana*, the *grue* that is also the French term for a high-class prostitute, like the woman portrayed. At such moments, seeing Manet also means reading him....

Finally, Manet is "literary" because his painting displays a complex relation to narrative. Although he ridiculed history painting, he nonetheless composed several of them, including multiple large-scale versions of the *Execution of Maximilian* (1867), as well as oil paintings of *Battle of the Kearsage and the*

Alabama (1864) and *The Escape of Rochefort* (1880–1), and a watercolor drawing of *The Barricade* (1871?). However, I am less interested in these self-proclaiming histories than in paintings where Manet hinted at narrative situations, a category that includes some of his most characteristic works—*Le Déjeuner sur l'herbe, Olympia, Interior at Arcachon, Masked Ball at the Opéra, Plum Brandy, The Railway, In the Conservatory, At Father Lathuille's,* and *A Bar at the Folies-Bergère.* Such pictures reveal his pleasure in playing narrative games, a pleasure that may exceed his desire to tweak the bourgeoisie. À la Poe, Manet delights in puzzles or mysteries, while his tone is cool and urbane—closer to Flaubert's.

*A*n excerpt from Arthur C. Danto's "Staring at the Sea: Édouard Manet." This article was originally published in *The Nation,* New York, 19 April 2004.

Manet's first known seascape was painted in a rush in 1864. It depicts a battle that took place on June 19 off the coast of Cherbourg between the USS Kearsarge and the Confederate battleship CSS Alabama—a decisive naval engagement of the American Civil War, since the marauding Alabama had single-handedly disrupted commerce between France and the Union. Exhibited about a month later, it is a brilliantly imagined painting, whose dramatic subject is reinforced by the urgency of its execution. Manet was an *alla prima* painter: He did not build an image up through glazes but worked directly on the canvas with the same hues the finished canvas would have, so the final stages of the work would preserve the vivacity it had in the beginning. The painting was, like most of his work, done in his studio; he was not, that is, standing behind his easel on the Norman coast when the Alabama's engines exploded, as in one of Mark Tansey's spoofs. He read about the battle in the morning papers, and based his composition on Dutch paintings of sea battles. Manet characteristically made use of art-historical models. *Déjeuner sur l'herbe* notoriously exploits Giorgione's *Fête Champêtre* in the Louvre, as well as a lost *Judgment of Paris* by Raphael, known through a famous engraving by Marcantonio Raimondi. His *Olympia* appropriates Titian's *Venus of Urbino.* No stigma attached to these borrowings—it was standard artistic practice. The Louvre was essentially a research facility for French painters, and, if anything, the ability to recognize allusions was part of the pleasure of looking at art. Originality lay elsewhere.

Concise Bibliography

Adler, Kathleen. *Manet*. Oxford: Phaidon, 1986.

Bataille, Georges. *Manet*. Trans. Austryn Wainhouse and James Emmons. New York: Rizzoli International Publications, 1983.

Cailler, Pierre, and Pierre Courthion, eds. *Portrait of Manet by Himself and his Contemporaries*. Trans. Michael Ross. London: Cassel & Company Ltd., 1960.

Crary, Jonathan. "Unbinding Vision: Manet and the Attentive Observer in the Late Nineteenth Century." In *Cinema and the Invention of Modern Life*. Berkeley: University of California Press, 1995.

Duret, Théodore. *Manet and the French Impressionists*. Trans. J. E. Crawford Flitch. Philadelphia: J. B. Lippincott Co., 1912.

Gleizes, Albert, and Jean Metzinger. *Cubism*. London: T. Fisher Unwin, 1913.

Harris, Jean C. *Édouard Manet: Graphic Works; a Catalogue Raisonné*. New York: Collectors Editions, 1970.

Harris, Nathaniel. *The Paintings of Manet*. London: Hamlyn Co., 1989.

Mauner, George. *Manet, Peintre-Philosophe: a Study of the Painter's Themes*. University Park: Pennsylvania State University Press, 1975.

Reed, Arden. *Manet, Flaubert, and the Emergence of Modernism*. New York: Cambridge University Press, 2003.

Schneider, Pierre. *The World of Manet, 1832-1883*. New York: Time-Life Books, 1968.

Tinterow, Gary, Genevieve Lacambre, Deborah L. Roldan, and Juliet Wilson-Bareau. *Manet / Velázquez: the French Taste for Spanish Painting*. New York: Metropolitan Museum of Art, 2003.

Zola, Émile. *His Masterpiece*. Trans. E. A. Vizetelly. New York: Marion Co., 1915.